IMAGES
of America

GROTON

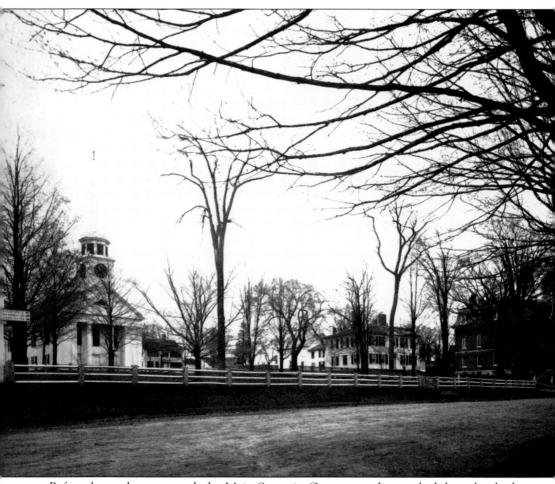

Before the roads were paved, the Main Street in Groton was dirt, packed down by the heavy steps of horses, the turning wheels of carriages and stagecoaches, and the feet of farmers, businessmen, housewives, and schoolchildren. The sign standing at the foot of the First Parish Church green directs travelers south and east to Littleton, Concord, and Boston. (Courtesy Groton Historical Society.)

ON THE COVER: The first train station in Groton was constructed in 1844 in South Groton. In 1848, the railroad came to Groton Center, and this station was built parallel to an old cart route. The depot was replaced several times over the years before passenger service to Groton Center ended in 1934. (Courtesy Groton Historical Society.)

IMAGES
of America

GROTON

Groton Historical Society

ARCADIA
PUBLISHING

Published by Arcadia Publishing
Charleston, South Carolina

Printed in the United States of America

Library of Congress Control Number:2009932192

For all general information contact Arcadia Publishing at:
Telephone 843-853-2070
Fax 843-853-0044
E-mail sales@arcadiapublishing.com
For customer service and orders:
Toll-Free 1-888-313-2665

Visit us on the Internet at www.arcadiapublishing.com

History is life. This book is for those who have made and told the story of Groton and to those who will continue to do so.

CONTENTS

ACKNOWLEDGMENTS

Groton is fortunate to have always been home to people who truly care about preserving and sharing the past. This dedication is evident in the old houses that line the streets and the volumes of histories in the library. There are countless people, both historical and contemporary, who deserve thanks for this. Zoë Eleftherio, Carl Flowers, Ruth Rhonemus, and Martha Gilson are all owed particular thanks for sharing personal photographs included in this photographic history. Their accompanying memories are just as valuable to the overall composition of this book. Gratitude is also due to Leroy Johnson for his graciousness in remembering and sharing what life was like in Groton in earlier days. Thank you also to Earl Carter whose vast knowledge of Groton lent accuracy to the text. All of this much-appreciated assistance enhances the story told on the following pages.

Many resources were used in preparing this book, including Caleb Butler's *History of Groton*; Samuel Green's historical writings; various Groton Historical Society publications; *Groton at 350, An Historical Sketch of the Town of Ayer*; local newspapers; family genealogies; and personal memories. Facts were also gleaned from documents and ephemera in the historical society's holdings.

The images of this book are comprised of photographs, postcards, letters, and ephemera. All come from the collection of the Groton Historical Society unless otherwise noted.

Thanks, finally, to everyone who has recognized the importance of saving photographs, writing down family memories, and remembering the way things were.

—Groton Historical Society Book Committee
Kara Fossey
Barbara Spiegelman
Elizabeth Strachan

INTRODUCTION

The history of Groton starts at the beginning.

Groton is at the heart of Nashoba Valley in central Massachusetts. The Nashua and Squannacook Rivers run through the area, and the landscape is decorated with many lakes, ponds, and hills. The native peoples who lived in the region called it Petapawag, "a swampy place." There was fertile farming land and ample waterpower for mills. This made the area now known as Groton an ideal land to settle. On May 23, 1655, the General Court in Boston granted a petition for the plantation of Groton. The land grant consisted of 64 square miles. Deane Winthrop, one of the petitioners, chose to name the settlement Groton, after his place of birth, Groton, England. In 1656, the town again petitioned the general court, this time to ask for reprieve from taxes for three years, citing the reason as "the remoteness of the place."

When colonists first arrived in Groton in 1655, they built modest homes, a trading post, and some mills. John Tinker's trading post was located by the river now known as the Nashua. As was customary at the time, Tinker paid a fee to the General Court of Massachusetts for the privilege of doing business with the native peoples. The earliest written town records start in the year 1662. Around this time, the settlers started to spread out in the village and divide up the land that was given to them, clearing it and erecting more buildings. The first meetinghouse was built several years later in 1666. Five garrison houses were built as community gathering places in case of threats from natives. Those who came to Groton recognized the dangers of living in a frontier town but none imagined the clashes with the natives would haunt them until 1723—almost 70 years after colonists arrived in the area.

The fiercest of these attacks was on March 13, 1676, when the town was assaulted by Nipmucs, who burned down every building in town save for four garrison houses. Settlers fled to Concord and Boston and returned two years later to rebuild after King Philip's War had ended and life seemed safer.

In 1694, during King William's War, life was again disrupted in Groton by Nipmuc attacks. As in King Philip's War, settlers were killed and buildings were destroyed, but in this war, the Nipmucs began to take prisoners. William and Deliverance Longley lived on a farm about a mile and a half outside the village with their eight children. One morning in 1694, a band of Nipmucs let the Longley's cattle out of their enclosure to draw the family outside. The ploy worked, and William and Deliverance were killed along with five of their children. The three remaining children were taken captive, one died while in captivity, and the two remaining children were taken to Canada. The killings and abductions continued throughout the early 18th century. In 1724, John Ames was the last man killed in Groton by native peoples.

The middle part of the 18th century was characterized by the loss of much land in Groton. In 1715, the first of several settlements to pull away from Groton was incorporated into a new town named Littleton. Over the next 150 years, more portions of Groton were lost to neighboring towns. Twice Groton was granted other large plots of land in compensation for its dwindling farmland.

In 1775, 200 men gathered at the town center to join the battle of Concord and Lexington. The men were given ammunition from the powder house located near the meetinghouse. A prayer service was held before the troops mustered out. Two Groton companies headed off to Concord, commanded by Capt. Henry Farwell and Capt. Asa Lawrence. These companies arrived after the battle ended but stayed to march and fight in subsequent battles, including the battle of Bunker Hill. Several Groton men, however, had set out for Concord the previous evening and joined other troops in fighting at North Bridge.

After the Revolutionary War was over, life in Groton settled down again. In the 1780s, higher taxes were being forced upon the people of Massachusetts. Shay's Rebellion was an uprising led by farmers in the state. Many of them struggled to pay the newly required taxes. In agrarian towns such as Groton, this burden affected many. In 1786, Job Shattuck organized a party of men to go to the Court of Common Pleas to interrupt court sessions. Shattuck was later arrested for his lead roll in Shay's Rebellion.

Education had always been important in Groton and this was evident in the academies that were set up in the late 18th- and early-19th centuries. Groton Academy was founded in 1793 to provide a higher level of education for both boys and girls. By 1823, however, girls were relegated to a special program that was not equal to the boys' program. Around this time, Susan Prescott set up a school for girls right next to Groton Academy. Although the school was only open for about 10 years, it taught women in a variety of capacities, offering training in writing, reading, orthography, grammar, geography, and needlework.

Before 1855, the year of Groton's 200th anniversary, there were many firsts in town. In 1829, Groton's first newspaper, the *Groton Herald*, was printed in a building near the Groton Inn. In 1847, the new Groton Cemetery was built. In 1848, the first railroad tracks came through the center of town. In 1850, a post office was established in West Groton, and in 1854, the Groton Free Public Library was established.

The history of the next 100 years is told through the photographs that follow. The story that these photographs tell is not intended to be a comprehensive history but rather a cross-section—a glimpse of life in Groton during the years from 1855 to 1955. There are countless people, places, and events that are not mentioned in this book. Although they are not mentioned, they all remain important in their contributions towards forming Groton into the town it is today. The following photographs may not illustrate the whole story, but they capture the true character and ideals of the town.

Photographs of buildings, whether they are houses, mills, churches, or schools, tell an important story of necessity, progress, and development. Photographs of people, groups, and events tell the story of the human spirit. A picnic by the river depicts a family relishing time together. A town hall draped in black captures a community in mourning. And picking up after swollen floodwaters tells of perseverance and the innate desire to restore balance, order, and integrity.

One

THE NATURAL LANDSCAPE

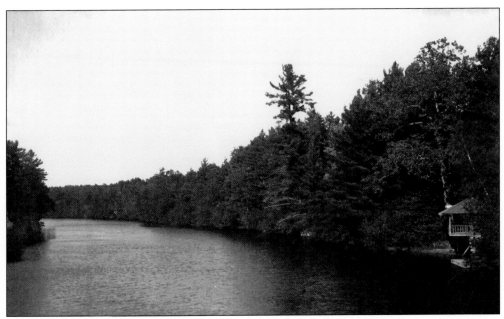

Groton began as a frontier town, and colonists first settled along the Nashua River using its water for power, travel, and food. They were also able to follow trails cleared by the native peoples. The river was known by several different names in the early history of Groton, including the Groton River and the Lancaster River. Before a permanent bridge was built, there was simply a shallow crossing place on the river.

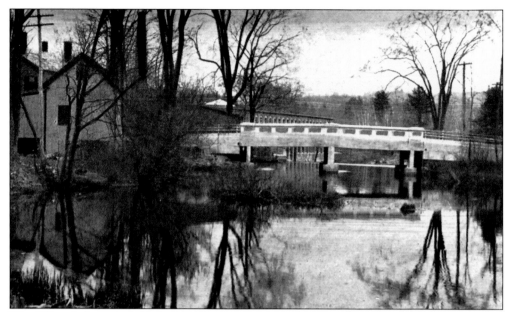

The 15.9-mile-long Squannacook River forms the western boundary of Groton and eventually flows into the Nashua River south of Groton near Ayer. As others did in surrounding areas over time, settlers found the Squannacook River an ideal location to set up mills and utilize the waterpower that was generated.

James Brook flows south and west through Groton before meeting the Nashua River in Ayer. The origin of the name of James Brook is disputed, but it is a name that was given early on in the town's development. The Indian Roll contains the earliest written records in Groton—1662 through 1707—and James Brook is mentioned numerous times. Caleb Butler reported in his *History of Groton* that there were once nine town bridges over James Brook.

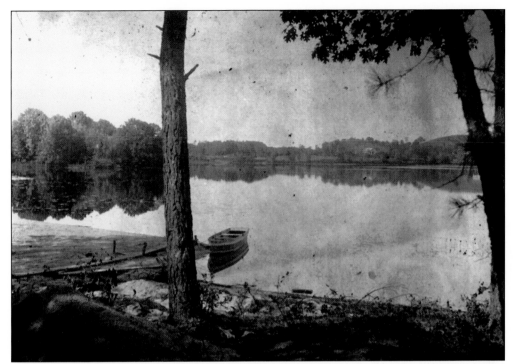

Baddacook Pond is a large body of water in the eastern part of Groton. It is located several miles from the center of town near Lowell Road. As is true with most of the natural resources in Groton, Baddacook Pond was mentioned in early-17th-century records. Baddacook Brook flows from Baddacook Pond to nearby Whitney Pond.

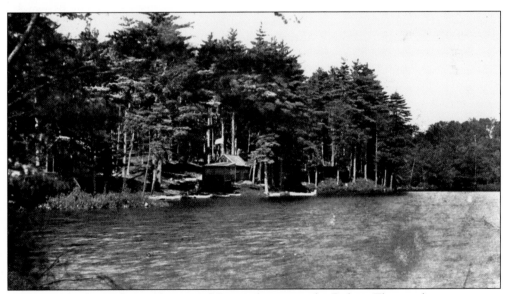

Knops Pond is located near the part of Groton known as the Ridges. The pond owes its name to James Knapp or Knop, an early settler who owned land in the area in the 17th century. The original Knops Pond dam was removed and Cow Pond Meadows was flooded to create Lost Lake, which became a summer vacation destination in the 1920s.

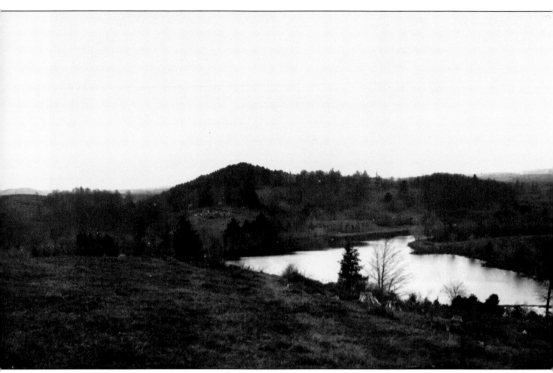

The landscape of Groton is dotted with numerous lakes and ponds. Martin's Pond is at the foot of Gibbet Hill and was probably formed when glaciers cut into the land and left piles of debris. This debris forms a sort of wall that blocks drainage. Once the glaciers melted, the depression was filled with water. Martin's Pond was named after William Martin, who lived near the pond. His dwelling was likely situated on what was an early roadway or trail that wound through the landscape. The following excerpt, which appeared in the *Daily Chronotype*, is from a poem written by Elizor Wright, once the principal of Groton Academy: "Reverting ere we reached the top / We saw the sheen of Martin's Pond / And thought it worth a little stop / The trees bent o'er it, all so fond / Of looking at their precious selves / The place is wild enough for elves."

Early Groton records show many areas designated as meadows, which referred to low-lying land that was used by farmers to mow. Farmers were given small plots reached by a common road. The common road giving access to Broadmeadow ran parallel to James Brook. This road running through Broadmeadow was an early roadway that now connects Main Street to Farmer's Row and is marked by several old farmhouses.

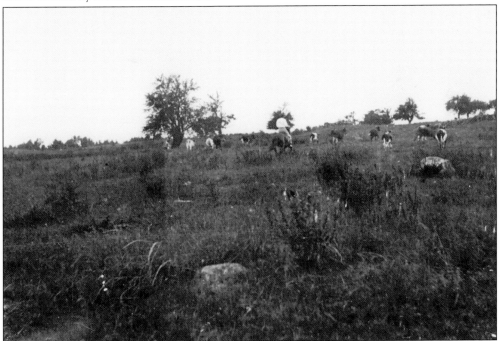

Throne Hill, known also as the Throne, is the highest hill in West Groton. Over 100 acres on the Throne are under conservation restriction, and the public is able to visit and enjoy the property. Here a man rides a horse up to the summit to round up a herd of cows.

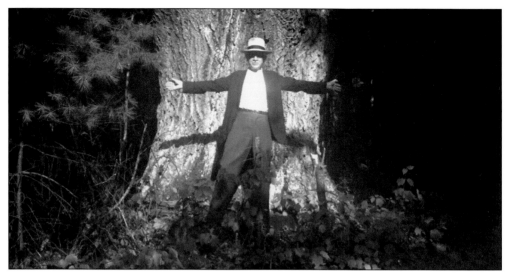

While Groton has always maintained much wooded land, the streets and farms of the town were once mostly bare of trees. During the 19th century, many trees were planted along the roadways, but the town was always conscious of the locations of trees that had been standing for hundreds of years. Roy Bennett stretches his arms to show the width of a huge oak tree on Reedy Meadow Road in 1954.

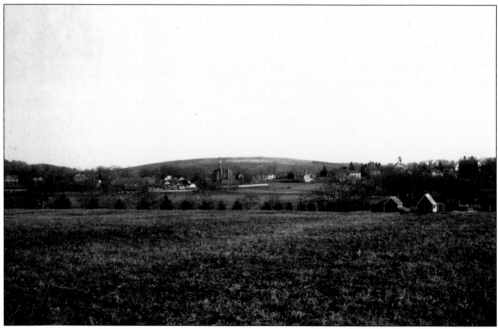

Groton was carved out of a nearly untouched wilderness and still takes pride in its beautiful natural landscape. This 1903 view of Groton from Farmer's Row captures the true character of the town that was evident in earlier days and that remains today: a small town nestled between hills respectfully coexisting with the landscape.

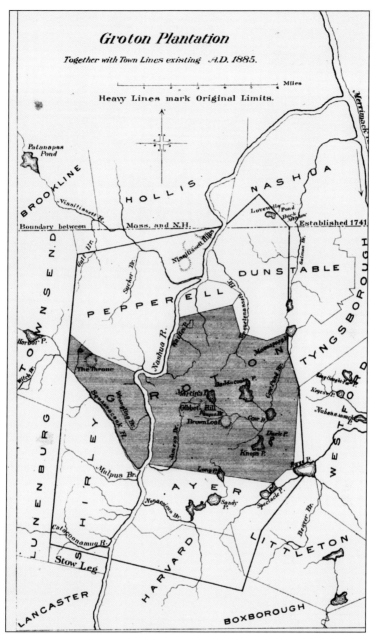

The original land grant to proprietors in what would become Groton was a large tract of 64 square miles. Included in this land was what is now Groton and Ayer and most of Pepperell and Shirley. Large parts of Dunstable and Littleton were inside the lines as well as parts of Harvard, Westford, Hollis, and Nashua, New Hampshire. The only lines that did not change were those that separated Groton from Townsend and Tyngsborough. When this land was granted, the closest settlements to Groton were Lancaster to the southwest and Andover and Haverhill to the northeast. Each of these settlements was between 14 and 25 miles away from Groton. The original boundary lines on the map are outlined with a heavy dark line, and the current area of Groton is shaded. Today Groton is less than half its original size.

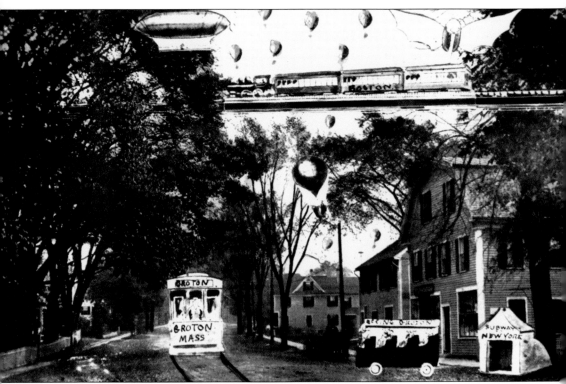

Groton's future can never be predicted, but it can be guessed at. This early-20th-century postcard shows "Groton, Mass., in the Future." The Main Street, looking much the same, is crowded with forms of transportation that can even take one to New York City. An elevated rail above the streets is on its way to Boston. The entrance to an underground subway station points the way to New York City. A trolley car rides on tracks down the middle of Main Street, and a bus is parked at the sidewalk. Various balloons and other flying contraptions signify all modes of possible transportation. All of these images are juxtaposed with the original horse and carriage in the photograph. In a way, this image was correct in its playful depiction of Groton "in the future." Today Groton does retain its small-town character and historic Main Street. And, arguably, the most changed aspect of life in Groton is made possible by advances in communication and transportation.

Two

CHARACTER AND
COMMUNITY

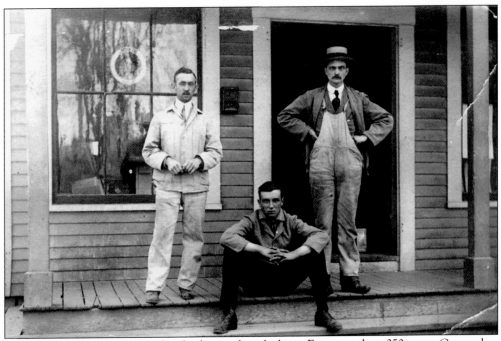

Towns are shaped by the people who live and work there. For more than 350 years, Groton has been home to farmers making a living, men and women fighting for the future of their town and country, politicians lobbying for new policies, and dedicated historians detailing important events. Both publicly important and charmingly ordinary people have molded Groton into the town it is today. Here "Sig" Chase (left), George Stevens (right), and an unidentified man pose on the porch of a Groton business.

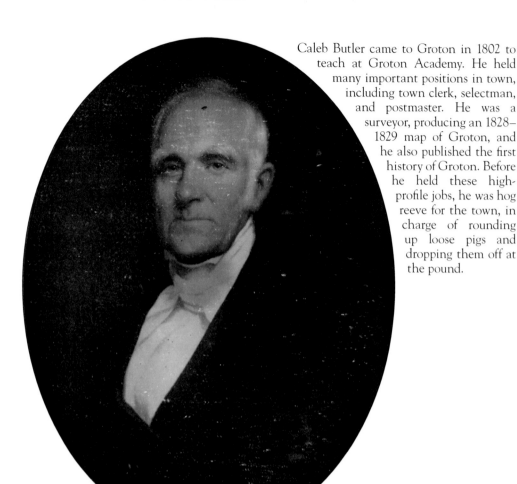

Caleb Butler came to Groton in 1802 to teach at Groton Academy. He held many important positions in town, including town clerk, selectman, and postmaster. He was a surveyor, producing an 1828–1829 map of Groton, and he also published the first history of Groton. Before he held these high-profile jobs, he was hog reeve for the town, in charge of rounding up loose pigs and dropping them off at the pound.

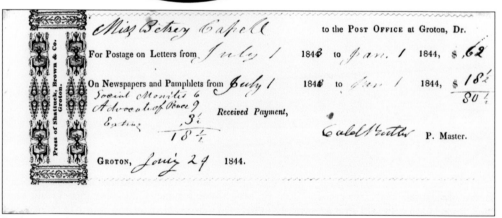

Butler served two different terms as postmaster in Groton: 1826 to 1839 and 1841 to 1847. Mail was delivered by coach on post roads, and once railroads were set up, it arrived by that mode. As postmaster, Butler signed off on Betsey Capell's receipt for postage during the year 1843. In the early-19th century, the recipient, not the sender, paid for postage.

Clarissa Butler was the oldest child of Caleb and Clarissa Varnum Butler. Like her father, Clarissa was interested in promoting education. She was elected to the Groton School Committee, one of the first women in Massachusetts to serve in such a capacity. She served as secretary of the school committee until her death in 1875.

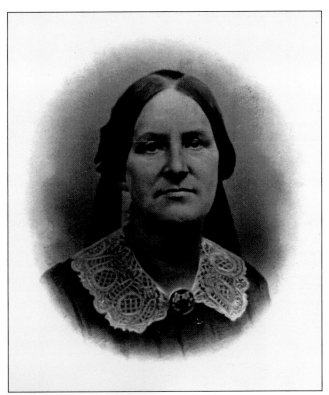

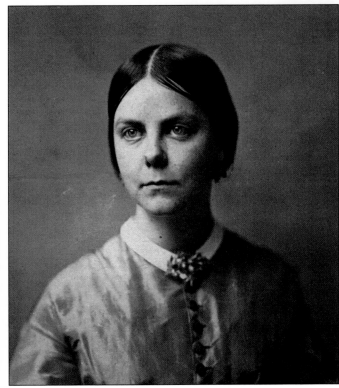

Frances Owen was a young schoolteacher in Groton. She taught in a room of the First Parish Church. During the 19th century before rules governing schools became stricter, it was not uncommon for classes to meet and schools to be set up outside the district schoolhouses. Churches or meetinghouses were common buildings in which to hold classes since they inherently functioned as community gathering places.

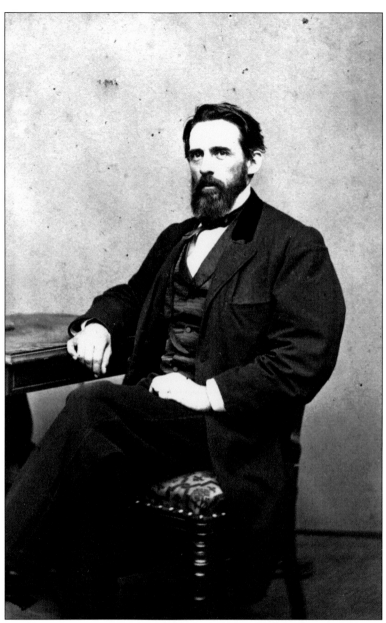

George Boutwell was born in 1818 in Brookline and spent his childhood in Lunenburg. After teaching briefly at a one-room schoolhouse in nearby Shirley, Boutwell arrived in Groton in 1835 and, after six months working in one store, began work for Henry Woods in his store on Main Street. After two years, Boutwell told Woods that he was leaving to study law. At that point, Woods offered Boutwell a partnership in the store if he would stay in Groton and continue to work. Boutwell agreed and continued to run the store even after Woods's death in 1841. In 1851, Boutwell was elected governor of Massachusetts for two terms. In 1862, he was appointed as the first commissioner of internal revenue by Pres. Abraham Lincoln. In 1869, he became secretary of the treasury under Pres. Ulysses Grant. It was during his term that Black Friday, a scandal involving the rise and plummet of the price of gold, occurred, and he dealt with the aftermath, which included his receiving written death threats.

Boutwell married Sarah Adelia Thayer on July 8, 1841. They had two children: Francis Marion and Georgianna Adelia. The children were born four years apart in the 1840s. Georgianna took care of her mother, Sarah, for many years as she was too sick or weak to leave the house. Sarah died at the family's home in March 1903.

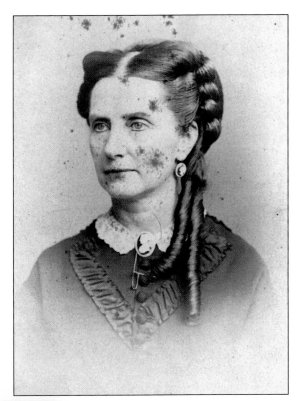

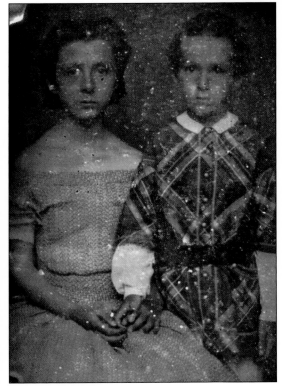

This early image of Georgianna Adelia and Francis Marion Boutwell was probably made in the early 1850s. The two children lived with their parents in Groton but moved to Washington, D.C., when their father's job demanded his attention at the capital. Both shared an interest in history and helped found the Groton Historical Society. Francis Marion compiled several local history booklets.

Georgianna Boutwell attended school in Groton, first at district number one schoolhouse and later at Lawrence Academy. She founded the Groton Historical Society in 1894 and the Groton Woman's Club in 1913. She was asked once what it was like living with a father so prominent in political affairs. Her thoughts on the matter were that he was a father just like any other, and "Children generally, I think, have a good deal of hero worship naturally . . . I think I was quite willing to do as he thought best . . . We were never ordered to do anything—we were asked in the same spirit that one would ask a friend . . . When we were corrected in pronunciation he told us not to take his opinion, but to go to the dictionary, never to take anyone's opinion but to find out for ourselves."

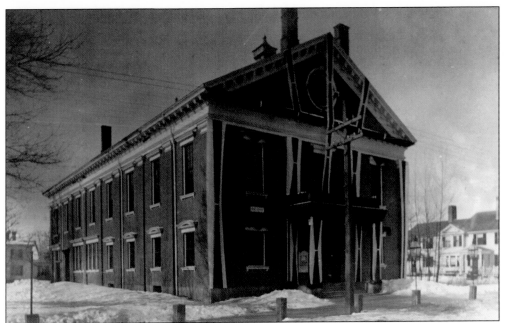

Groton's town hall was draped in black and white fabric in mourning for George Boutwell, who died on February 27, 1905. His funeral was held on March 2. The inside of the town hall was decorated with "massed quantities of floral offerings." It was publicized after his funeral that he was in debt at the time of his death. Georgianna later remembered fondly that her father's character was honest and kind, and "While it is true that all the comforts of life are obtained by the use of money, I am thankful every day of my life that my father thought money a poor exchange for an upright character."

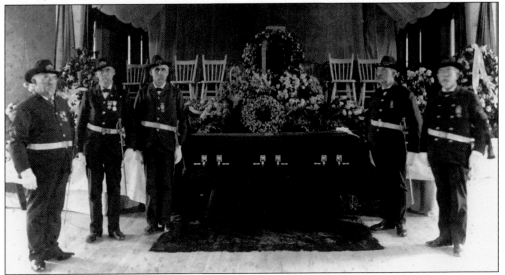

George Boutwell was laid to rest in a black casket. Two palm leaves tied with a purple ribbon rested upon the casket. Businesses closed down for the day and school classes were cancelled. His pallbearers and ushers were made up of political and personal friends. No eulogy was made at the request of the family. The officiating pastor affirmed that his life achievements spoke loudly enough.

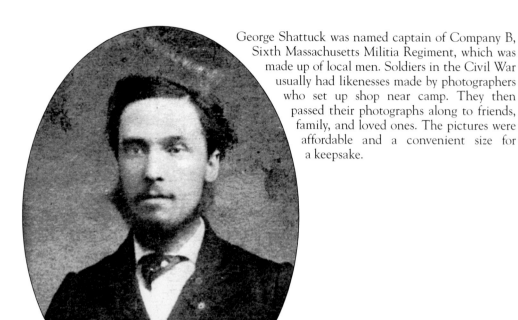

George Shattuck was named captain of Company B, Sixth Massachusetts Militia Regiment, which was made up of local men. Soldiers in the Civil War usually had likenesses made by photographers who set up shop near camp. They then passed their photographs along to friends, family, and loved ones. The pictures were affordable and a convenient size for a keepsake.

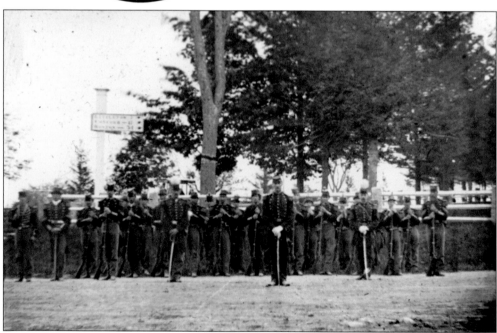

Company B originated as an old volunteer militia company known as the Groton Artillery. This was one of the companies in the Sixth Regiment that marched through Baltimore on April 19, 1861, and remained in battle as the Civil War continued. This photograph was taken on Main Street in front of the First Parish Church green after a ceremonial parade.

Moses Palmer was not a native of Groton but worked in town during the 1850s in a shoe factory. Palmer captained a regiment during the Civil War but was wounded at the Battle of Gettysburg. After his discharge, Palmer returned to Groton, where he was active in town affairs, serving as selectman, assessor, and overseer of the poor.

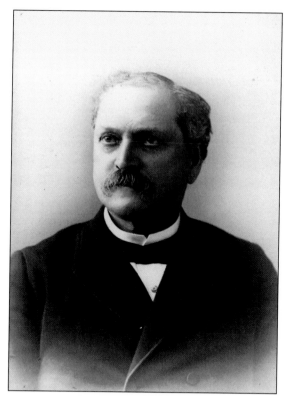

Moses Palmer kept a journal for several years while fighting in the Civil War. The July 1, 1863, entry documents the injury he received at Gettysburg: "Marched at 8 o'clock towards Gettysburg 7 miles . . . arrived and formed in line of battle . . . went to the front . . . hard fight . . . shot in the knee." He continues to write about having the ball removed from his knee but calls it a "bad wound."

Moses Palmer built a three-story building on Hollis Street, which became known as Palmer's Block. Many different businesses occupied this block over the years, including several meat markets. This gentleman ran a laundry business on the site. The building burned and was rebuilt as only two stories.

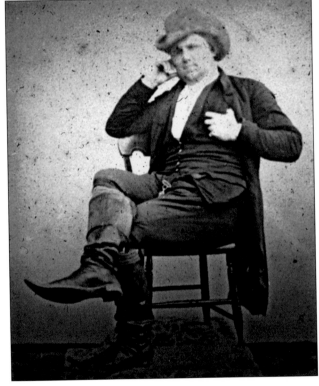

Hibbard P. Ross lived and conducted business in Groton Junction as a soap peddler. He told stories, jokes, and used a wheel of fortune to garner more business. When district school number 12 was auctioned in 1855, Ross purchased the building and used the bricks to construct part of his soap factory on Tannery Street.

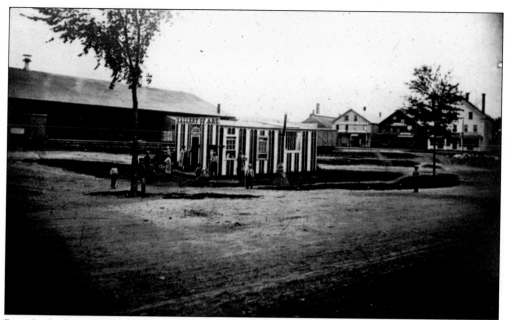

Ross built this gallery of art in 1862. It was originally located at Camp Stevens, a Civil War camp at Groton Junction. Soldiers had their likenesses done in the building that was called the "Striped Pig" for its red, white, and blue exterior decoration. After Camp Stevens was abandoned, the gallery was moved into the village.

AUCTIONEER.

H. P. ROSS,

THE original "Soap Man," will be ready to attend Sales of Real Estate or Personal Property in any part of the country. Being situated at Groton Junction, he can appear anywhere, in an incredible short space of time.

In the June 22, 1867, issue of the *Middlesex Worker*, an advertisement for Ross calls him the "soap man" and mentions his new venture as real estate auctioneer. Much in keeping with his penchant for amusement is the declaration that he can "appear anywhere, in an incredible short space of time."

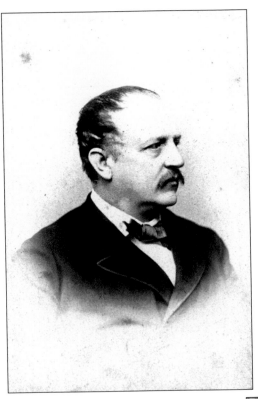

Samuel Green is probably best known in Groton as a historian. He wrote many books and smaller booklets on various aspects of Groton's history. He did not just dedicate time to pursuing research but continued to be involved in a variety of activities that interested him. His long and varied career includes serving as a surgeon in the Civil War, a city physician of Boston, the mayor of Boston, and a librarian of the Massachusetts Historical Society.

Nathan Nutting lived at his home between Boston Road and Old Ayer Road with his wife. They were known around town as being rather poor and keeping to themselves. On May 16, 1887, Henry Winch visited the Nutting house and demanded to be given hard cider. Nutting refused, and Winch chased him up the stairs where Nutting shot him dead. In a display of solidarity, the town backed Nutting and insisted that he was constantly harassed and had acted in self-defense.

Brothers Amory and William Lawrence were born near Boston, where they continued to live and go to school. After Amory graduated from Harvard College, he began to spend weekends in Groton where his cousins lived. He enjoyed the beautiful landscape and clear air. While working on a committee at Harvard to construct a class of 1870 memorial gate, he thought it a shame to dispose of the old gate, so he had it shipped to Groton.

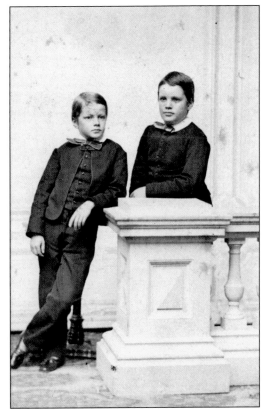

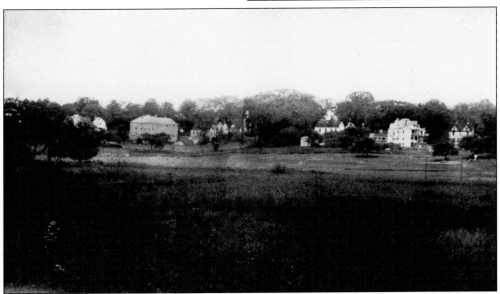

Amory Lawrence donated 14.5 acres of land off of Main Street to the town. His wish was that the land be kept as a playground to honor the many generations of the Lawrence family that had lived in Groton. He erected a stone gate with the materials he had rescued from Harvard. The playground was equipped to handle popular sports, and there was a baseball and football field, as well as tennis and basketball courts.

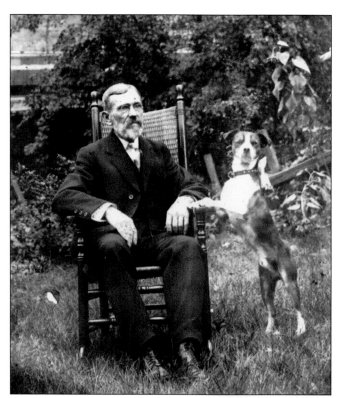

William Wright (1852–1931) lived and worked in Groton Junction and later in Ayer. He was a prominent undertaker, and advertisements in the local paper showed that he owned a store where he made furniture and also specialized in coffins and other funerary necessities. Wright was an amateur photographer and took many pictures of Groton, Ayer, and surrounding communities that document local life in the late 19th and early 20th centuries.

William P. Wharton (standing) was a graduate of the Groton School and Harvard College. Here he is posing with friends at the Groton School. After graduation, he built a small house near Baddacook Pond and continued to buy up parcels of land in the area. Eventually he amassed 717 acres of land and donated it to the New England Forestry Foundation in 1968. Wharton's other interest was birds, which he banded at his Five Oaks Farm in order to record their travels and activities.

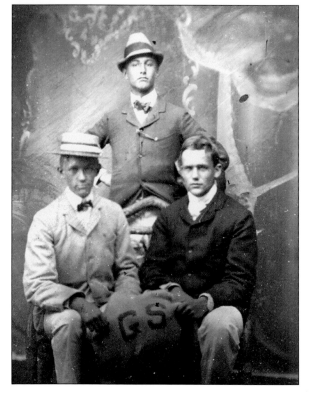

Three

AGRARIAN BEGINNINGS

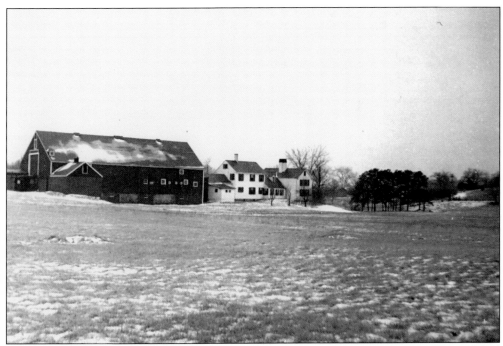

Like many early towns lying far from the nearest city, Groton was set up as an agricultural community. The land was given to the settlers to farm and harvest crops, which could be sent to Boston. Underhill Farm, as it was once named, is a typical farm with a comfortable farmhouse and large barns and outbuildings to accommodate livestock. All this is surrounded by fields ripe for planting or pasturing.

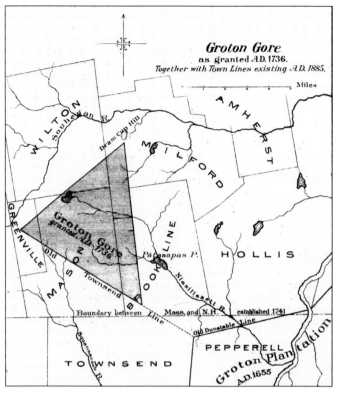

Groton Gore
as granted A.D. 1736.
Together with Town Lines existing A.D. 1885.

Groton lost land to Nashoba, now Littleton, in 1714. To make up for this, Groton was granted a triangular parcel of land, comprised of over 10,000 acres, between Townsend and Dunstable. Each spring, cows were driven up to Groton Gore to pasture. When the state line was drawn, Groton lost that land to New Hampshire, and it now includes parts of Greenville, Mason, Brookline, Milford, and Wilton.

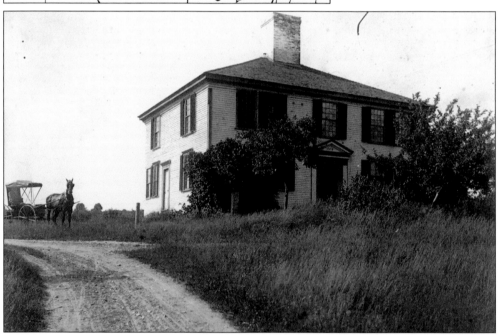

Known as the Moors house, this residence stands on land that was owned by the Moors family from 1716 to 1850. While Benjamin Moors lived here, he maintained a hop field and a hop house. When Aaron Mason bought the property in 1850 in the middle of the Temperance movement, he promptly disposed of the hops and burned the hop poles for firewood.

In 1843, this farm near the Dunstable town line was purchased by Nicholas Fitzpatrick. His son James soon moved to the house and bought cows to breed and equipment to furnish the farm. The Fitzpatrick farm became one of the largest dairy farms in the area, with the herd number hovering around 14. Only a couple of other farms in Groton had close to 20 cows. (Courtesy of Carl Flowers.)

James Fitzpatrick Jr. (right, seated) moved back to the Fitzpatrick farm after his parents died in the mid-1800s. Soon after, he sold almost half the acreage of the farm. By 1920, the livestock on the farm had dwindled to three cows, two horses, a colt, and a hog. He died in 1938, and his wife died in 1943. After standing empty for five years, the farm was purchased in 1948 by Elmer Carlson and Esther Silveus. (Courtesy of Carl Flowers.)

During the middle of the 19th century, Simeon Ames owned a house and farmland that had previously belonged to his father. During the 1850s, he began to sell off parcels of his property. This auction poster is dated 1863 and cites poor health as the reason for selling. The details that the poster focuses on illustrate what elements were important to people during the 19th century. Not only does the farm offer plenty of land, but the land could be used for pasture, planting crops, or as an orchard. The location of the farm is stressed as well: "The Farm is situate 1 1-2 miles from Groton Centre and 1-4 of a mile from District School." These terms are meant to entice a prospective buyer. Being reasonably close to town ensures that one can visit the village for supplies or entertainment. The property's close proximity to a school is ideal for a family that has children. Most everyone young enough to purchase a large, functioning farm would have had school-age children.

Groton March 20th 1860

We hereby acknowledge with shame to Mr Rufus Moors that we did wrongfully and wickedly take from him a large Swarm of Bees and honey on Sabbath evening and carried them away and destroyed the Bees, and carried away the Honey which was all wrong and for which we feel truly sorry and will gladly pay for said Bees and Honey and humbly ask your forgiveness and promise in future to treat you with kindness and gratitude and henceforth to be of Good behaviour

Eben Tufts
Albert Ames
Warren J Jewett

Looking at Caleb Butler's map of 1828–1829, one is able to locate the property of Rufus Moors a short distance away from the farm belonging to Simeon Ames. As evidenced by this letter, Moors raised bees in order to collect honey. Ames's son Albert is one of the three teenagers apologizing in this 1860 letter for taking the bees from his property: "We hereby acknowledge with shame to Mr. Rufus Moors that we did wrongfully and wickedly take from him a large swarm of Bees and honey on a Sabbath evening and carried them away and destroyed the Bees, and carried away the honey which was all wrong, and for which we feel truly sorry and will gladly pay for said Bees and Honey and humbly ask your forgiveness and promise in future to treat you with kindness and gratitude and henceforth to be of good behavior . . . Eben Tufts, Albert Ames, Warren Jewett."

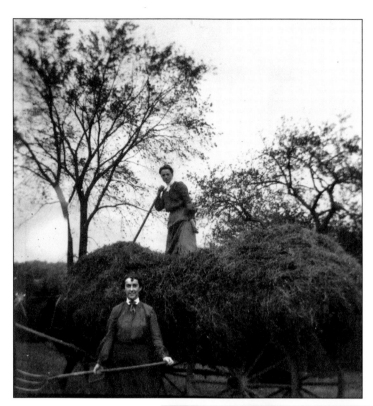

Women did not typically do much work outdoors around the farm, but this began to change in the 20th century. Not only was it more acceptable for women to be outside doing chores, but many also needed to learn their way around farms in the event that their husbands were sent to war. Here two unidentified women wield pitchforks and work with a large mound of hay on the wagon.

This family no doubt had a significant patch of garden devoted to growing these large gourds. Gourds are one of the world's oldest domesticated plants. Despite this, many varieties of gourds are not consumed as food. Their ability to grow to large sizes, makes them a popular choice for exhibitions. This is likely what these women were preparing for them for.

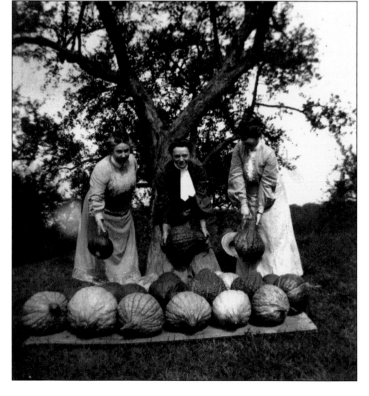

Countless children in Groton grew up on farms or visited nearby farms of family or friends. And with so many farmers in town and so much focus on agricultural life and groups like the Grange, the Farmers and Mechanics Club, and the Groton Fair, it is little wonder that children picked up on the importance. In this photograph, Roy Bennett holds a small farming tool and stands in front of a wheelbarrow loaded with straw.

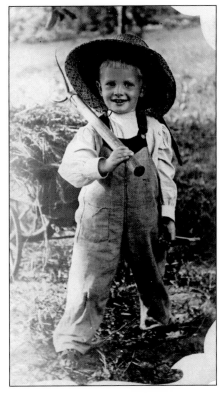

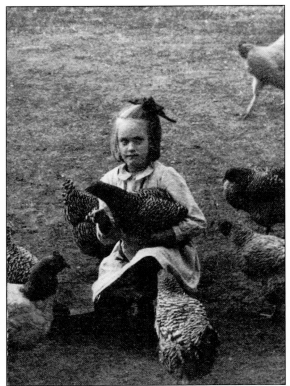

In this similar photograph, Ruth Bennett, sister of Roy, holds a chicken in her arms while others strut around her. Whether picking up skills that would be useful in their own future farms or just enjoying the environment of their rural community, children were helpful in gathering eggs, milking cows, and other chores.

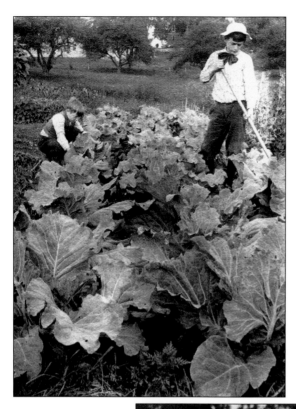

Cabbage was just one of the many vegetables grown on Groton farms. In fact, it was one of the most popular vegetables planted by children in their school and home gardens. Its extensive use is probably due to its hardiness. Cabbage is quite easy to grow in the proper conditions.

Many farms would not be complete without a chicken coop on site. Traditional 19th-century chicken coops included both a covered shelter for the chickens and an open yard enclosed with a wire fence. The chicken coop in this photograph is small enough that the owners likely just kept the eggs for their own use, although they may have traded with neighbors for other goods.

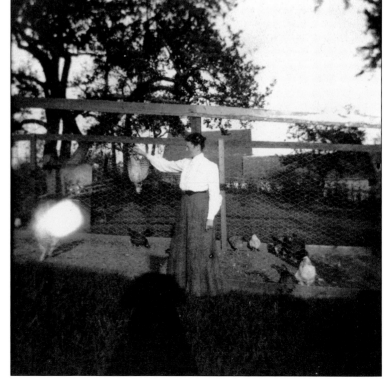

The Groton Grange was established in 1873 as the seventh Grange organized in Massachusetts. In fact, the Groton Grange is the oldest continuously active Grange in the state. The Grange is an organization of people committed to promoting local agriculture. Although times have changed and it is perhaps not realistic to return to an agrarian society, the Grange is still relevant in its mission to improve life in rural towns.

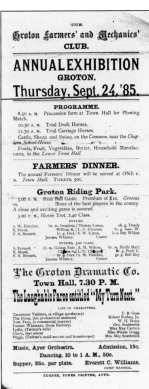

The Farmers and Mechanics Club was started in the 19th century to promote agriculture in Groton. It sponsored a yearly fair at Hazel Grove Park, where there was an exhibition hall, as well as a trotting park for horse races. This program advertises the 1885 annual exhibition, which included contests and races. A dinner was served at the town hall and a comedy show was featured in the evening.

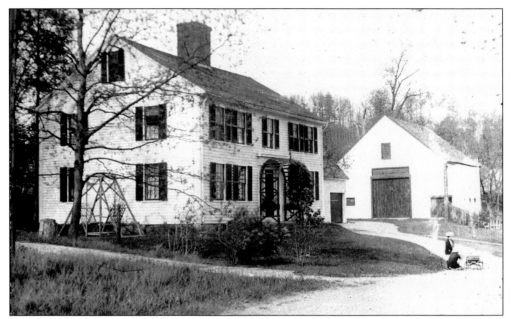

Howard Gilson lived on Lowell Road with his wife and children and managed their 55-acre farm called Hillside Orchard until the late 1930s. The house was built around 1750 and was purchased in 1795 by Jonas Gilson. The farm was kept in the family for over 100 years following. Between the house and the barn was the apple shed where apples were sorted and packed. (Courtesy of Martha Gilson.)

Hillside Orchard was made up of approximately 55 acres, comprising land on both sides of Lowell Road. Over 600 trees bared 10 different species of apple. Peaches, cherries, and several types of nuts were also grown. In the left foreground, an old water trough is visible. This supplied water to horses that were driven down the road. The town paid the Gilsons yearly for maintaining the trough. (Courtesy of Martha Gilson.)

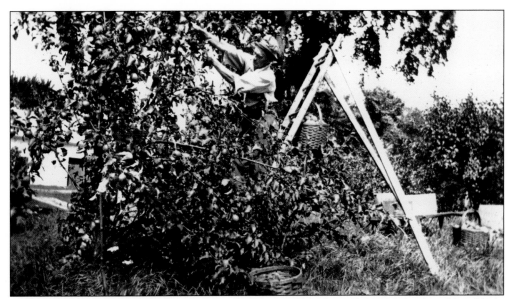

Howard Gilson picked apples from his trees and pruned the branches. He also hired local help for the orchard during the harvesting season. The apples were sold to wholesalers in the state. He delivered the apples directly to Lowell but hired someone to make deliveries to Boston. (Courtesy of Martha Gilson.)

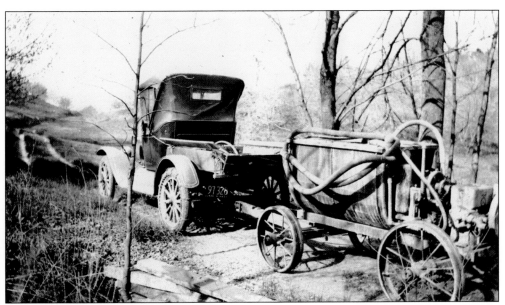

Howard Gilson owned this truck, which he drove through the orchards and around the farm. He was able to tow a sprayer behind it to tend to the trees. He had a gasoline tank installed at the farm so that he could fuel up at home as needed. In November 1936, he paid $33.75 for 250 gallons of gasoline. (Courtesy of Martha Gilson.)

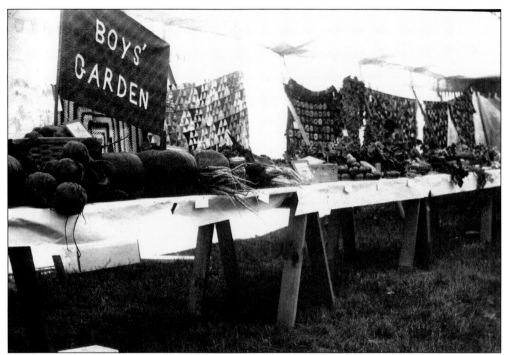

The Groton Fair took place each year under the Farmers and Mechanics Club. It was held at the fairgrounds and offered a variety of shows and events. There were livestock exhibitions, horse races, and even fireworks. Students were also able to showcase their fruits and vegetables that were grown at the school gardens in town. One group mounted an exhibit of 53 insects found in gardens in Groton.

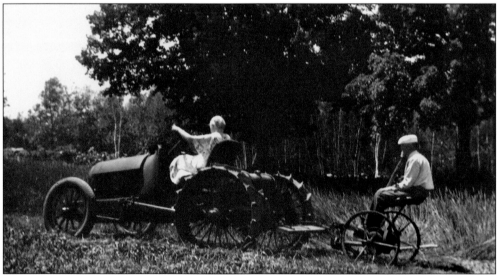

This photograph of R. F. Gilson and B. E. Gilson was taken in 1936 towards the end of the Depression. Clearly the couple found amusement in their ride around the farm—the back of the photograph is labeled "the Dinosaur." Their outdated machinery may have years left in it or it may be a sign of the tough economic times, which kept some people from purchasing more updated equipment.

Four

A Tradition of Learning

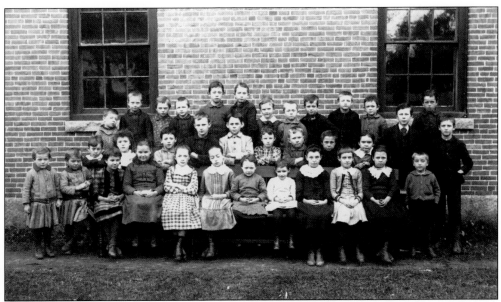

Groton has always been a town concerned with quality education. As early as 1681, the importance of elementary education was noted in the town records. The town continued to pursue educational opportunities, as academies, district schools, centralized schools, private schools, and public schools were laid out to provide the best that could be offered. This school photograph from about 1887 captures a class of young minds destined to learn, grow, and give back to Groton.

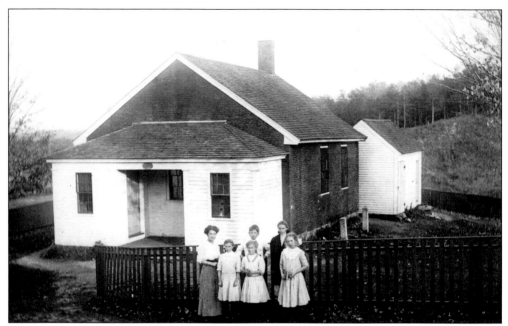

District school number seven, later known as the Chicopee School, was built for students residing in a northern section of town. The children varied in both age and gender. The school closed in 1900 due to low enrollment but opened up again six years later. The school closed permanently in 1915. The four children attending Chicopee School were transferred to the new Boutwell School closer to the center of town.

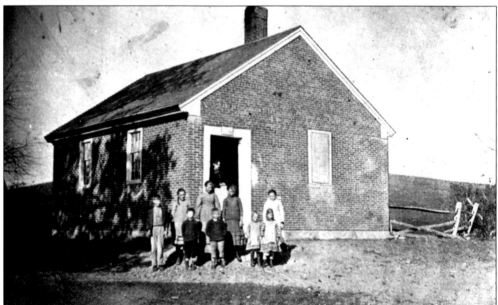

District number nine school, or the Willard School, was at the corner of Lowell Road and School House Road and was discontinued before the dawn of the 20th century. These one-room schoolhouses were not used just for holding classes during the day. Some opened in evenings for contests, such as public spelling matches. This gave townspeople a chance to socialize. Those that lived farther from the center of town surely appreciated a closer public place to gather.

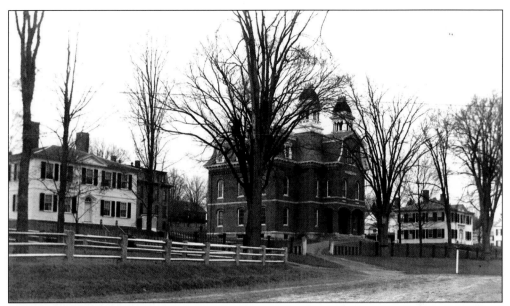

Groton Academy was founded in 1793 to provide a higher level of education that was not offered at Groton's district schools. The school was originally coeducational, and both girls and boys followed the same curriculum. Students did not live on campus but boarded in houses in the village. In 1846, the name was changed to Lawrence Academy after a sizable donation of land and money by Amos and William Lawrence.

The *Student's Aid* was printed by Lawrence Academy and was full of short essays and anecdotes relating to education. The first printing was in 1877, and there were three printings per year—one at the end of each term. This issue lists examination times and locations for November. Several pages inside, as well as the back cover, carry advertisements for local businesses.

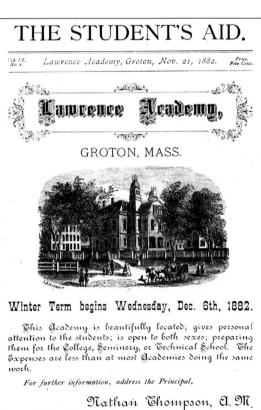

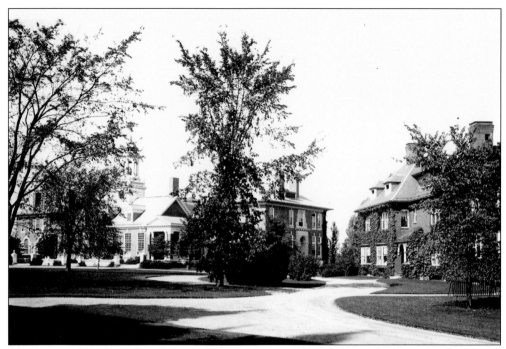

The Groton School was founded in 1884 by Endicott Peabody, who wished to see students grow intellectually and spiritually. Well-known graduates of the school include Pres. Franklin Delano Roosevelt, sports writer Peter Gammons, and photographer and founder of the Boston Museum of Science, Bradford Washburn.

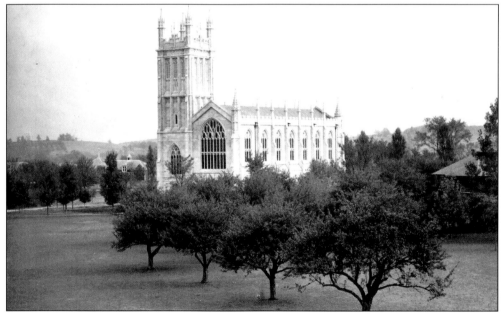

St. John's Chapel, an impressive stone Gothic Revival structure, was built at the Groton School at the end of the 19th century to replace the older, smaller chapel. Most buildings on campus are set up in a circle with a green common in the center, and St. John's Chapel stands near the main gates that mark the entrance to the school.

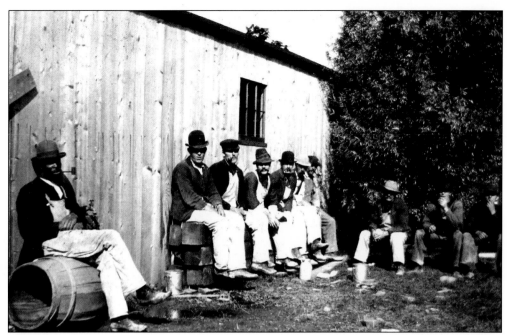

The first building on the Groton School campus was the Brooks House, named after Phillips Brooks, the first chairman of the board of trustees. Construction of more buildings followed. The photograph above shows workers at the Groton School around the dawn of the 20th century. In keeping with Groton's dedication to preserve history, the Groton School has purchased and used numerous old homes in the vicinity of the school.

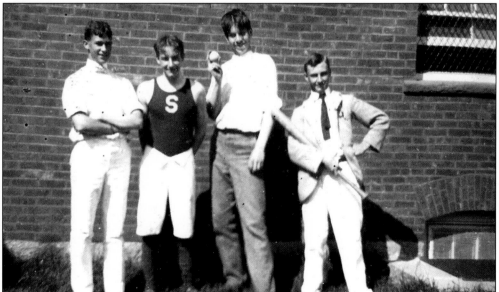

William P. Wharton took this personal photograph during his time at the Groton School. One of his friends is shown wearing a sports uniform with an S on it. This likely stood for the Squannacooks, one of the school's intramural teams. The school allowed the boys to go into town on Wednesdays and Saturdays, and a popular spot to gather was the soda fountain at Bruce's Pharmacy.

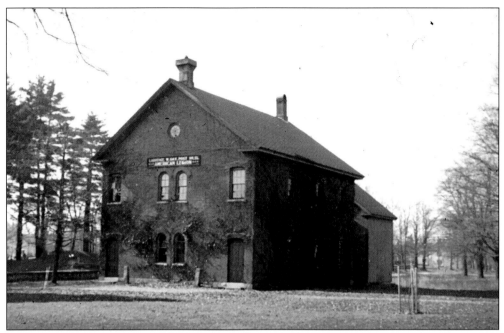

The Chaplin School, later used as Legion Hall, was built in 1869 to accommodate elementary school students from the center of Groton. Separate classes were taught at the Chaplin School, a real departure from the one-room schoolhouse. In 1896, the second floor of the Chaplin School was opened to make room for more students in several different grades.

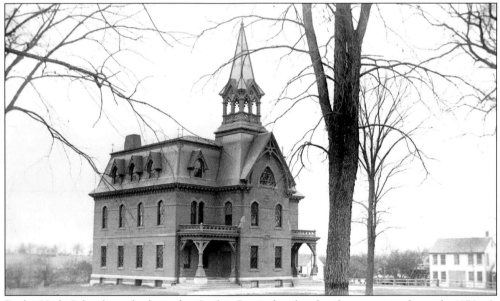

Butler High School was built in the Gothic Revival style of architecture in the early 1870s. It was named after town historian and surveyor Caleb Butler. Located on Main Street, the school became centralized when district schools began to close. A fire on the third floor caused the 1925–1926 school year to begin late. The school report from 1927 mentions "overcrowding, uneven heating, and poor ventilation" at the Butler School. Soon after, the school was torn down and a new one built on the same site. This picture was taken in 1895.

Nesbit Woods would have been about nine years old when this report card was issued. Butler High School did not just accommodate older children but taught classes of elementary schoolchildren until 1911, so it is likely that this was the school he was attending in 1882.

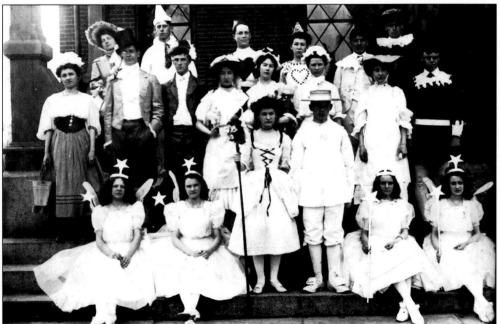

Pageants and other programs have long been an integral part of the school year. Here the students of the Butler High School class of 1907 are dressed for their parts in the school production of *Mother Hubbard*. The 1907 annual report tells that of all the graduating students in 1907, more than half continued their education at various colleges.

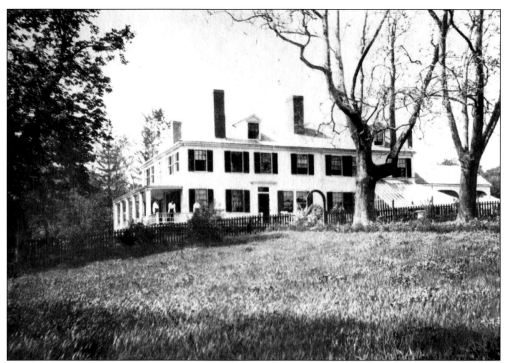

The Lowthorpe School of Landscape Architecture was founded by Judith Motley Low in 1901 to train girls in landscape design and horticulture. The main house was of the Greek Revival style, built in the 1820s. It sat on a 17-acre campus that included meadows, trees, shrubs, and flower gardens. Both students and faculty lived at the school, although some students were accommodated in the village.

THE SCHOOL OF HORTICULTURE AND LANDSCAPE GARDENING FOR WOMEN, AT LOWTHORPE, GROTON, MASSACHUSETTS, WILL OPEN SEPTEMBER 15, 1902.

THE COURSE INCLUDES HORTICULTURE, ARBORICULTURE, BOTANY, GREENHOUSE WORK, AND WORK IN THE FLOWER, FRUIT AND VEGETABLE GARDENS, ECONOMIC ENTOMOLOGY, AND ORNITHOLOGY, AGRICULTURAL CHEMISTRY, PLANE AND SOLID GEOMETRY, SURVEYING, FREE HAND AND MECHANICAL DRAWING, LANDSCAPE GARDENING AND GARDEN DESIGN.

THE COURSE IS FOR TWO YEARS OF TWO TERMS EACH.

TUITION, $100 A YEAR. PAYMENT SEMI-ANNUALLY. IN ADVANCE.

A FEW STUDENTS MAY LIVE AT LOWTHROPE FOR $30 A MONTH. OTHERS, IN THE VILLAGE NEAR-BY.

ADDRESS:

MRS. EDWARD GILCHRIST LOW
LOWTHORPE
GROTON
MASSACHUSETTS

When the Lowthorpe School first opened to students in the fall of 1901, there were only two requirements for entry: a high school diploma and good health. The Lowthorpe program boasted impressive faculty that came from schools such as Harvard College and the Massachusetts Institute of Technology. Others came with resumes full of well-known landscape design projects. The school was officially incorporated in 1909 and around that time was charging $100 per year for tuition.

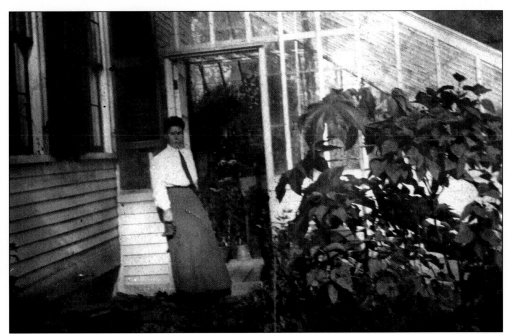

The 1901 greenhouse at Lowthorpe was full of plants raised from seeds that Low brought to the school. In the 1930s, the original greenhouse was still standing but needed to be either replaced or renovated. With money from a fund-raising effort, the Lowthorpe School spent $8,000 building a new greenhouse in 1933, with three different areas for cool and woody plants, general growing, and tropical plants.

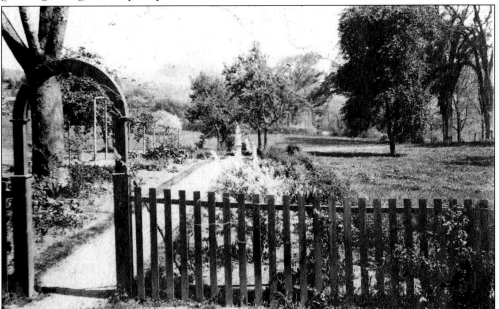

After the Lowthorpe School was founded, work began on the grounds and the gardens. This photograph from 1904 shows the path leading to the statue. In the spring and summer, beautiful flowers bloomed along the walkway. Over the years, there were many other gardens, including the Dawson Dell, framed by granite slabs from an old barn foundation, and a formal herb garden.

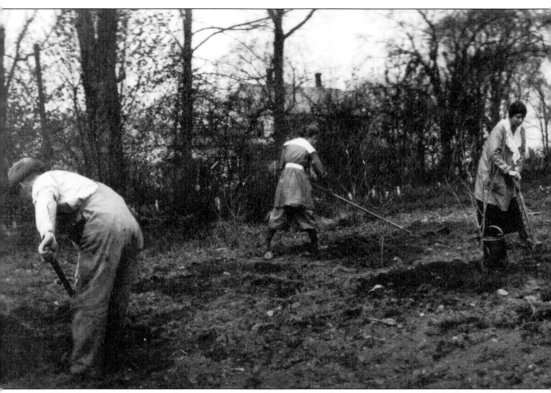

The Lowthorpe curriculum was vast and varied, and there were several different tracks the students could choose from and various types of hands-on training offered. Some of the courses that the students could choose from included drafting, surveying and engineering, entomology and soils, botany, elementary architectural drawing, and elementary forestry. In 1916, Richard Kimball came to Lowthorpe from Boston on the train to take photographs and write an article for *House Beautiful*. In his article, he stressed that the Lowthorpe School was not a finishing

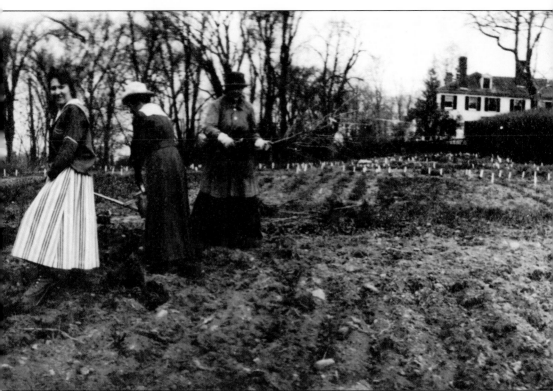

school. Women were out in the fields and in the drafting room, learning by doing. During World War I, the students at Lowthorpe were also taught to manage farms and were given lessons on running farm equipment. In the late 1930s, financial problems forced the school to reconsider its effectiveness in Groton. In the early 1940s, Lowthorpe approached five different schools to investigate a possible merger. Only one school responded, and in 1945, Lowthorpe officially closed in Groton and moved to the Rhode Island School of Design.

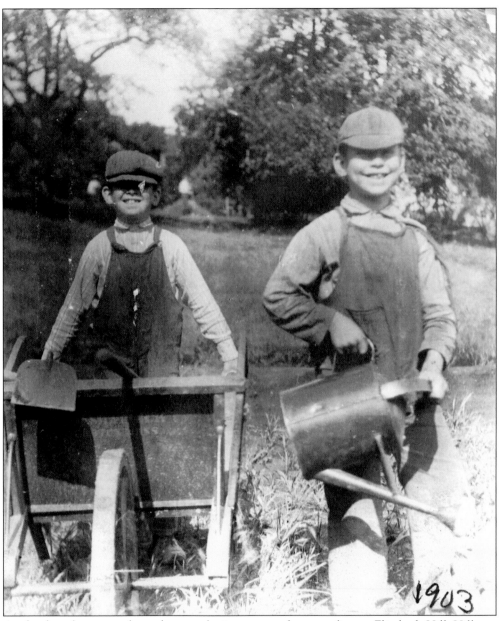

1903

A school garden was a place where gardening was taught, according to Elizabeth Hill. Hill was the first student to attend Lowthorpe and was the driving force behind the establishment of school and home gardens in Groton. Children worked twice a week during the school year and once a week during summers. Each child had their own plot to cultivate. The first school garden was set up at the Lawrence playground. That spot was abandoned when too many stray balls from the sports fields found their way into the gardens. Plots were then set up at Mr. Shattuck's land in the center of town, at the Chicopee School, at Mr. Sedley's farm in West Groton, and at Hill's home Willow Dell in West Groton. Residents of Groton donated fertilizer, plowing services, harrowing, use of land, and prize money. Seeds were donated by organizations such as the U.S. Department of Agriculture and Amherst Agricultural College.

The West Groton mill village garden was another parcel of land that children cultivated under the supervision of Elizabeth Hill. She made sure that the children were planting in an orderly, systematic way. They were taught that "a garden-line is a necessity." Seeds were planted in straight rows and were easily weeded and thinned out as they grew.

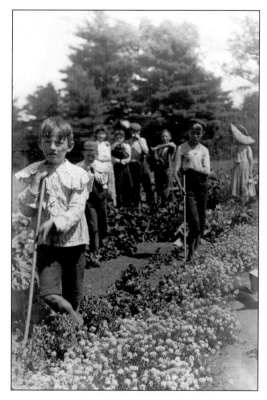

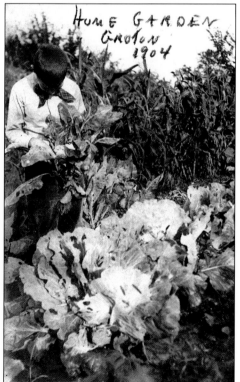

Almost every child who participated in school gardens also had a home garden. Hill worked in the Groton one-room schools for a half hour per month teaching nature study. During these sessions, she handed out packets of seeds and explained how to plant them at home and how to tend to the vegetables and flowers that grew.

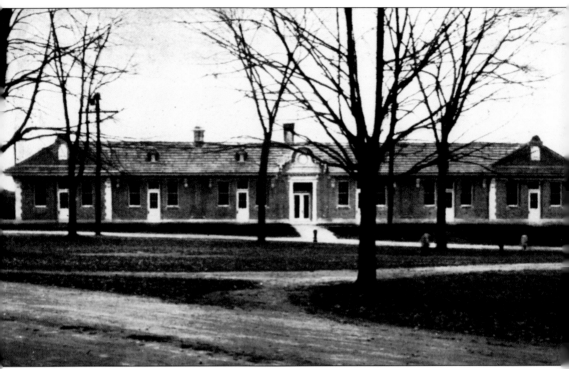

The Chaplin School, having been declared unsafe, prompted the building of a new school in 1915. This school was near the center of Groton and could accommodate the town's elementary schoolchildren. The Boutwell School was named after George Boutwell, who was secretary of the state board of education from 1855 to 1861. Georgianna Boutwell prepared a speech to thank the town for voting to name the school after her father. With her final lines, she expressed, "It is my hope that when the boys and girls of this village, which my father so much loved, see this picture of him upon these walls and from time to time learn of his life, it will inspire them to become upright men and women, beloved in their homes and so far as in their lives, that they shall be of service to the communities in which they live."

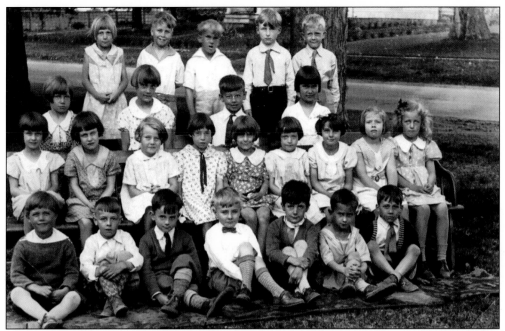

This photograph shows the Groton High School class of 1945 when they were in first grade at the Boutwell School. Examining the placement of the children in the composition, it is evident that girls were not allowed to sit on the ground in the front. The boys take care of that, but even they sit on a rug not directly on the ground. These group photographs were taken each year to document the classes.

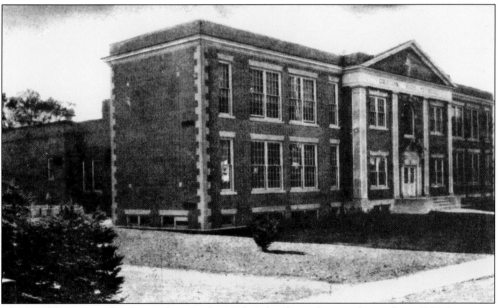

The need for a new school to replace Butler High School was discussed as early as 1901. It was not until 1928 that a new school was actually built. During this transition time, high school students were moved to classrooms in the old Chaplin School, the Grange, and the Odd Fellows Hall. Groton High School opened in September 1928 and accommodated grades seven through 12.

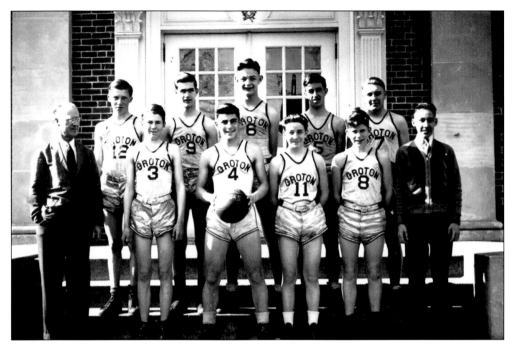

In the second quarter of the 20th century, schools and colleges began to stress the importance of experiencing both physical activity and classroom studies. Physical education classes were held once a week at the Groton High School. Interested and dedicated students could try out for a sports team. The teams practiced after school and played games in the evening. Here the 1944–1945 boys' basketball team poses on the steps of the school with coach Warner.

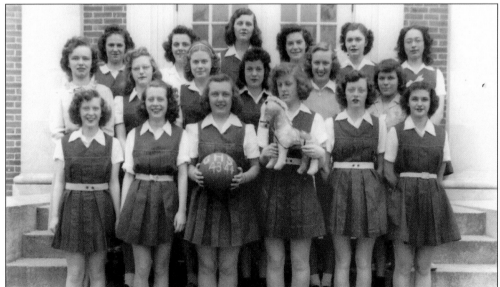

Groton High School offered sports to girls as well. In basketball, the girls played under different rules, however. The teams, like the 1943–1944 team pictured here, were set up in such a way that the girls could not cross mid-court. Instead they had to pass to their teammates positioned across the court. Many schools had these same rules and concerns that the girls should not run around too much.

Five

A ROOF OVERHEAD

Groton's streets are lined with houses built at various times over a period of 300 years. Grand village estates, expansive farmhouses, and modest colonials stand in all corners of town. Dating from 1706, this may be the oldest house standing in Groton. It was constructed after a decision at an April town meeting to build a "good house" for the Reverend Dudley Bradstreet.

This house stayed in the Woods family for close to 200 years. It was built around 1720, and an older gristmill originally stood on the property. The building was erected in the saltbox style, making it two stories in the front and only one story in the back. The origins of the saltbox style are likely a combination of necessity, evolution of form, and a way to pay less in taxes.

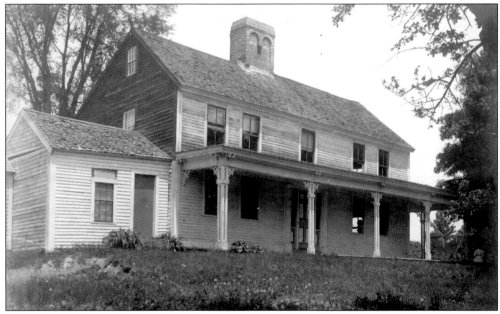

The Champney house was built around 1730. It now stands at the corner of Hollis Street and Champney Street, although Champney Street was not created until over 100 years after the house was built. This house was used as the earliest known tavern in Groton. In 1752, Caleb Trowbridge Jr. obtained a license to sell wine and spirits in the building.

The present-day Hollis Street was once a continuation of Main Street, so it is no wonder that both sides of the road are filled with a variety of old homes. The oldest houses on the road date to the early 18th century, and homes have continued to rise along there. Hollis Street has also been the home for many buildings or parts of ones that have been relocated from other areas in Groton.

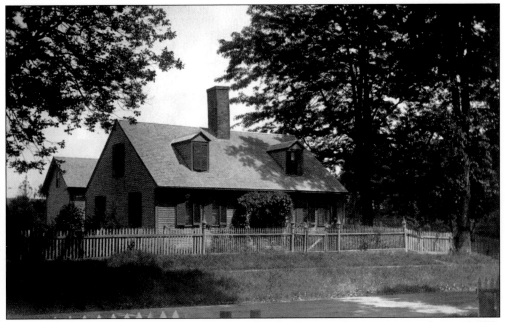

This Cape Cod–style house stands at the start of Hollis Street and was constructed around 1770. Over the years, it has been known as the Potter Place and the Aaron Perkins house. The dormer windows on the house were probably added at a later time to allow more light and headroom on the second floor.

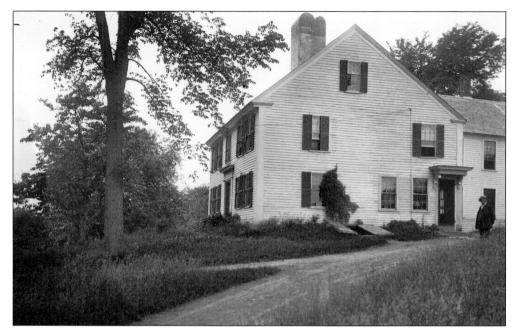

Joseph Raddin was born in 1841 in Groton. His father died when he was young, and Raddin went to work to help provide for his mother and sisters. He worked at a mill creating casks in which fish could be packed and shipped. Later in his life, Raddin owned a large farm on Lowell Road at which he is pictured standing above. The Raddin farm yielded successful crops of apples and peaches.

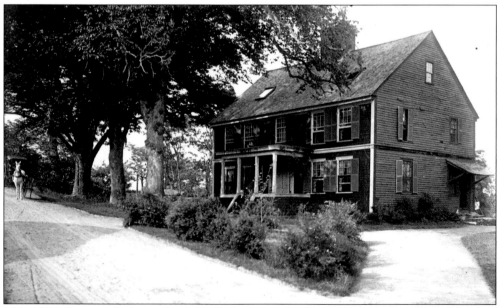

This 1907 photograph shows the Sawtelle homestead, which was built in 1772 by Ebenezer Patch, who later sold it to the Sawtelles. Although the photograph was taken many years ago, it is interesting to note the skylights on the roof, which must have been quite the modern fashion at the time. The horse and carriage coming down the road, on the other hand, represent an earlier time.

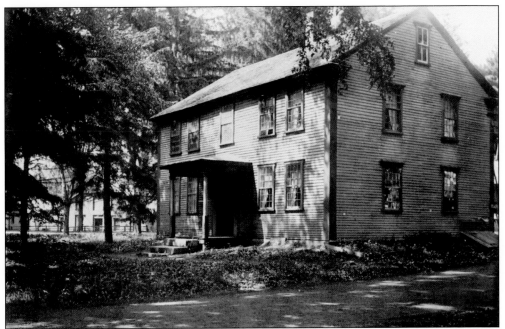

Situated by the Nashua River, this house was built by John Capell around 1800. The Capells kept a tavern in this house from around 1820. While some taverns were large stagecoach stops that had rooms for rent, many taverns were simply houses that were known to open up their doors for weary travelers. Some people would charge for a bed, while others hoped to sell goods or produce to the visitor.

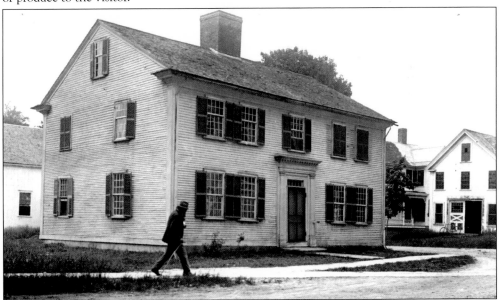

The simple composition of a man walking down the sidewalk in front of an old home conjures up questions about what life was like many years ago. In Groton in 1907, the year this photograph was taken, the Groton School reported 26 cases of the measles, there were 165 dog licenses issued, 5 people were living at the almshouse, 175 votes were cast against a town liquor license, and $36.50 in fines were collected at the library.

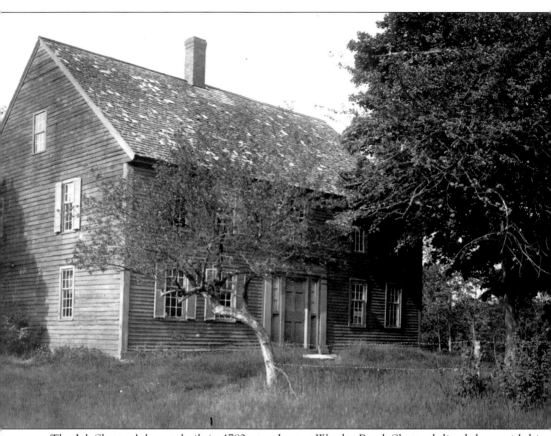

The Job Shattuck house, built in 1782, stands near Wattles Pond. Shattuck lived there with his wife, Sarah Hartwell Shattuck, and their nine children. Job fought at Concord and Lexington in 1775 and at the battle of Bunker Hill. While her husband was away during the Revolutionary War, Sarah stayed home and minded the farm like many wives at the time. Fearful of British spies passing through the area, Sarah joined a company of local women called "Prudence Wright's Guard." These women dressed in men's clothing and stationed themselves at Jewett Bridge in Pepperell, where one night they captured a man found to have treasonous intentions. After the war was over, in the early 1780s, Job organized a group of farmers and laborers to resist the taxes imposed by the state of Massachusetts during Shay's Rebellion. In 1786, Job led 200 men to the Middlesex County Courthouse in Concord in protest. A warrant was issued for his arrest, and he was picked up near his house in Groton. Despite a grim sentence of hanging, he was later released.

In 1829, Stuart J. Park built this house for his son John G. Park at the junction of Main Street and Old Ayer Road. In 1906, this property was in the hands of Lawrence Park, who decided to move the home to a new location. The house was put on wheels and moved up the hill and across the street, where it was used as part of a larger new house.

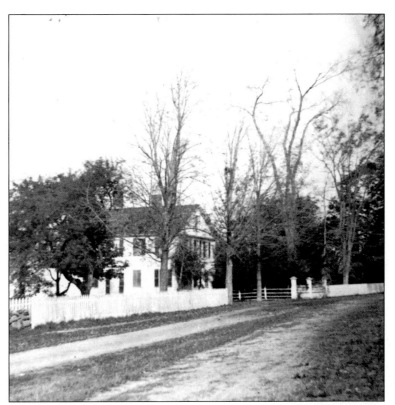

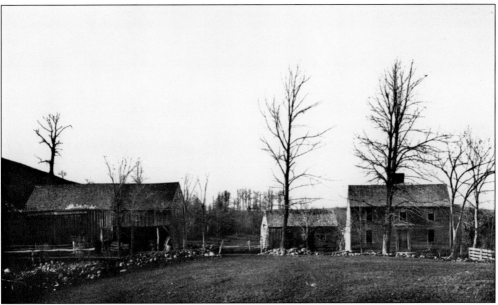

The Noah Shattuck house is one of the many houses that were moved to new locations in town. It originally stood on the north side of Martin's Pond Road. Some time after 1850, the house was moved across the street. Buildings in the 19th century were often moved to new foundations instead of being torn down. People were less likely to destroy a structure that had taken so much time and money to construct.

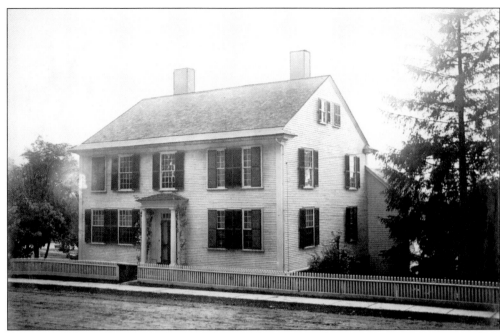

Caleb Butler built this center chimney dwelling house around 1806 on Main Street across from Groton Academy. The house was constructed with 12 over 12 windows, giving each window 24 panes of glass. District school number one was located near Butler's house and had no land of its own. Butler allowed schoolchildren to use water from his well and to make visits to his "necessary house."

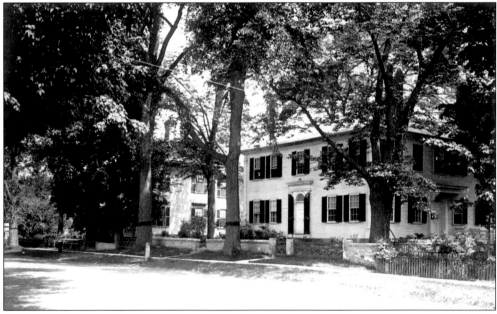

As is typical with many old houses, this structure is made up of parts of several different buildings. In the back is part of an 18th-century house where Groton's first baker, Charles Quails, lived with his wife. Luther Lawrence built the main part of the house in 1811 before moving to Lowell in 1831, where he became mayor and later died in an accident while he was touring a mill.

On November 11, 1855, Susanna Prescott was found on the floor in the kitchen of her house near the area known as the Ridges. She died soon after from her injuries and her caretakers George Francis Baker and his wife, Mary Ann Jane Baker, were tried for her murder. George was eventually acquitted, and Mary Ann was sentenced to serve life at the Middlesex House of Correction at East Cambridge.

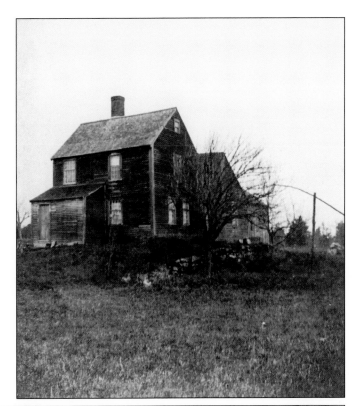

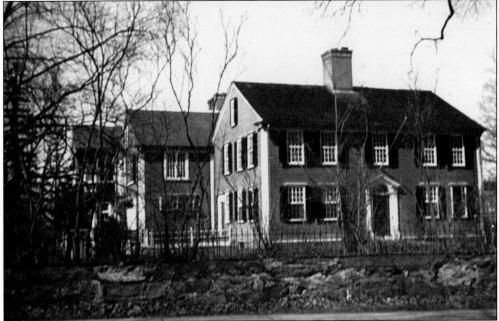

On this property in 1707, three Tarbell children, while they were picking cherries in the tree, were abducted by Native Americans and taken to Canada. Around 70 years later, Samuel Lawrence moved his family to the old Tarbell house. Lawrence tore down the house in the late 18th century, and this large house was built soon after with more wings added in the 19th century.

Oliver Prescott Jr. built this house for his wife on Old Ayer Road in the early 1790s, although they only lived there a short time. The house was soon purchased by the Sylvester Jacobs family, who lived there for over 100 years. Several walls in the house are covered in murals painted by Rufus Porter, an itinerant folk artist, and his assistant J. D. Poor, whose signature is found in one painted scene.

A detail of one of the murals in the Jacobs house displays Porter's typical style. Porter was a jack-of-all trades—an artist, musician, inventor, and founder of *Scientific American* magazine. He traveled up and down the East Coast, but his wall murals depicting trees, ships, and farms are found mostly in New England. His murals were not meant to be a depiction of a specific place but rather the essence of New England life and landscape.

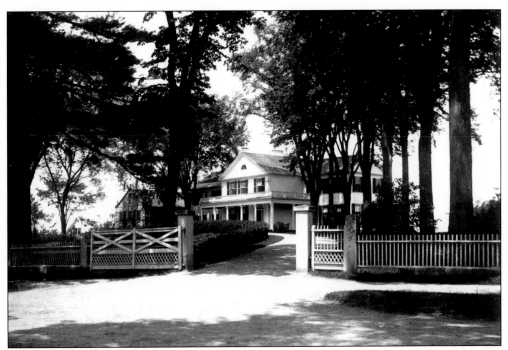

Known as the Elms, this house had a host of interesting owners during the 19th and 20th centuries. In the 1830s, Timothy Fuller, father of Margaret Fuller, a transcendentalist author who was schooled in Groton in the 1820s, purchased the house. In 1893, it was occupied by William F. Wharton, who had recently left a career in politics as a member of the Massachusetts House of Representatives and assistant secretary of state under Pres. William Henry Harrison.

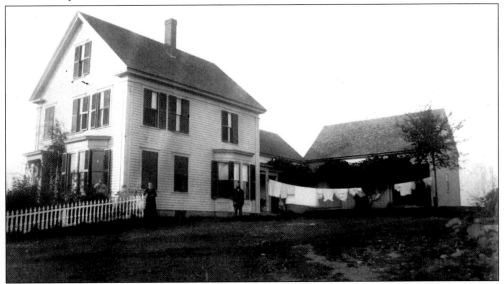

In the late 19th century, this house on Champney Street belonged to a family who owned a tailoring shop in the village. The style of this house borrows some elements from the Greek Revival style that was popular in the early 20th century. In this style, the entry is on the narrower end of the house, which faces the street, to mimic the design of ancient Greek temples. The bow windows on the house are of purely Victorian design.

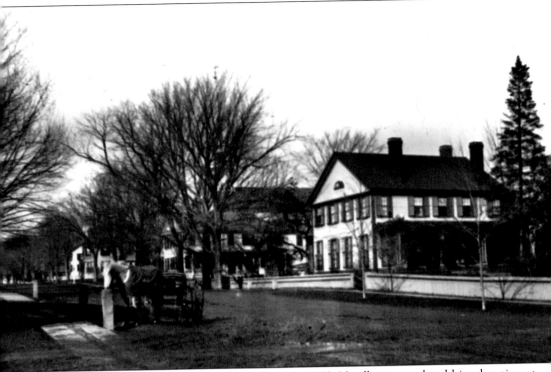

This house was purchased by Daniel Needham in 1863. Needham completed his education at Groton Academy when his family moved to Groton in 1840. Needham had a background in law and also served the state of Massachusetts as a representative and a senator in the 1860s. In addition to his career in law and politics, Needham remained dedicated to agricultural affairs. He managed several farms in Massachusetts and other states in the country. He was one of the founding trustees of the Massachusetts Agricultural College, later the University of Massachusetts. At various times, he was master of the Groton Grange and president of the Groton Farmers and Mechanics Club. Needham was town moderator for years. He was also primarily responsible for the creation of a public well, which was situated by the front of his yard. Many families benefited from this well during dry spells.

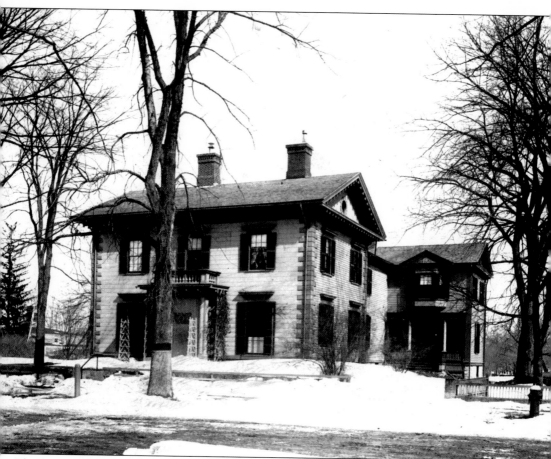

The Boutwell house was built in 1851 for the George Boutwell family. In 1869, when Boutwell was serving as secretary of the treasury, Pres. Ulysses S. Grant visited Groton. Boutwell remembered the occasion as such: "We arrived at Groton at about ten o'clock. The President was met by a very considerable number of the citizens. He was saluted by the discharge of an ancient, small sized cannon, and he was escorted from the station to my house by the Groton Brass Band. The next morning I gave the President an opportunity to see the town as far as it could be seen in a drive of an hour. He gave a public reception at my house between the hours of ten and eleven o'clock. In that time 3300 persons according to an accurate count, passed through the house and took the hand of the President." The house remained in the family until Georgianna Boutwell died in 1933, and it was bequeathed to the historical society.

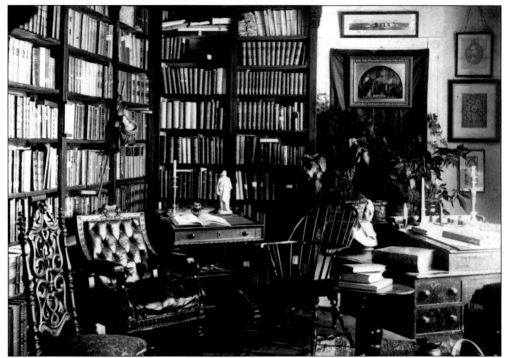

Several additions in the late 19th century were added to the Boutwell house to bring it to its current design. One of these additions included a new library for George Boutwell. The room was located on the second floor and had a bow window, which let much light in. Boutwell's library held his writing desk and a large collection of military reference books and volumes pertaining to political and legal matter in Massachusetts.

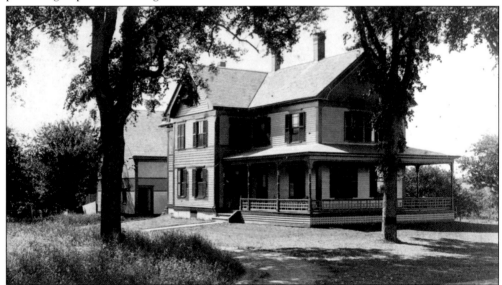

Franklin Earland Gilson was born in 1852 in Groton and opened up a dental clinic in town around 1880. An 1882 advertisement tells that Gilson was formerly with the Colton Dental Association in Boston. At this time, his practice in Groton was open every day during the week except Mondays. He built this Victorian farmhouse around 1887 on the road leading to Ayer.

Six

SERVING THE PUBLIC

The First Parish Church is the oldest public building standing in Groton. Built in 1755, this church was also Groton's fourth meetinghouse until the town hall was built in 1859. On July 26, 1795, lightning struck the steeple and the building partially burned. It is said that milk was used to extinguish the fire. In 1849, the church went through extensive renovations, including a quarter turn to face the west.

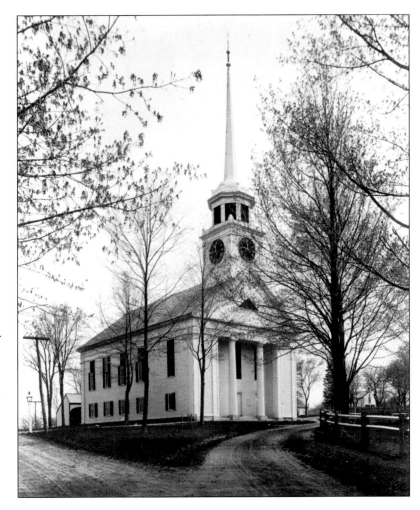

In 1780, Jonathan Keep purchased a house and land on the main street in Groton. The next year, it opened as Captain Keep's Inn to serve travelers passing by in stagecoaches and for cattlemen driving herds to Groton Gore for grazing. His building was added on to numerous times, and by the late 19th century, the inn was made up of parts of several different buildings moved on to the site.

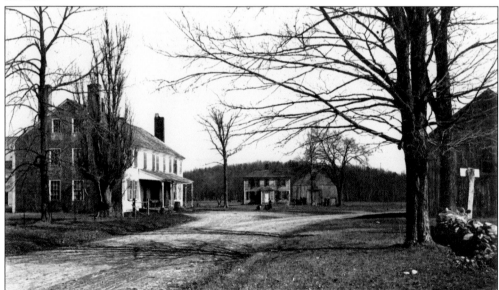

The Ridge Hill Tavern was constructed in 1805 at the fork of two roads leading to Boston. It was situated right on the road to make it easy for drivers to drop off their passengers. At one time, as many as 40 stagecoaches passed through Groton each day. The name of the tavern is taken from the area of Groton in which it stands, known as the Ridges due to its land formation.

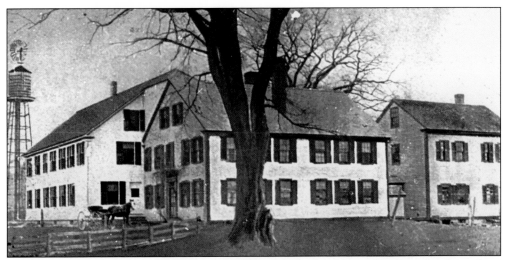

The town poor farm was built in 1822 to house those who had no means of supporting themselves. Residents of the town farm were expected to raise vegetable and livestock for food. Besides those who lived at the farm, transients often stopped by for food or an overnight stay. These numbers rose sharply in the aftermath of the Civil War. Residency declined into the 20th century, and the poor farm closed in the late 1920s.

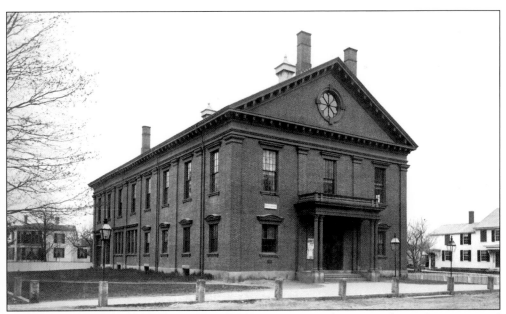

Groton's town hall was built of brick in 1859 on Main Street at the center of town. It was not used just for official town business and meetings. There were many social activities and gatherings for townspeople to attend. The town hosted dances, live shows, music, and lectures within its public building. This photograph was taken in 1894 and shows a post office sign hanging above one of the windows.

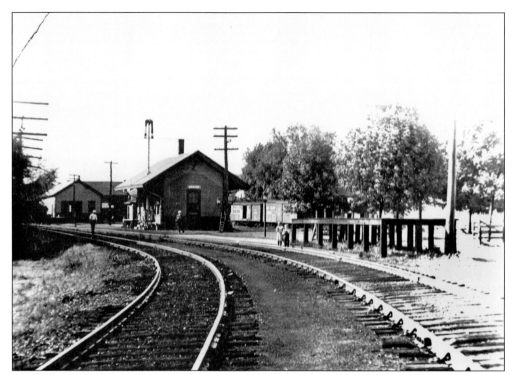

Trains bridged the time between stagecoaches and automobiles and greatly expanded the capacity to travel and to transport goods. Passengers could regularly take the train to Ayer to shop for groceries and clothing. They could also travel to Maine and New Hampshire for vacations and to New York City on an overnight sleeper car. The first tracks were laid through Groton Center in 1848.

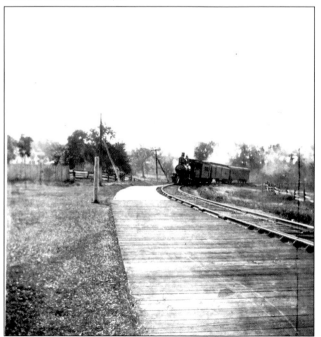

In the early 20th century, there were 10 to 12 passenger trains that rolled into Groton every day along with many freight trains. Every train brought mail, and those that arrived in the morning picked up and carried milk from Groton farms to customers in Boston. There was also a daily train from Maine to New York City via Groton.

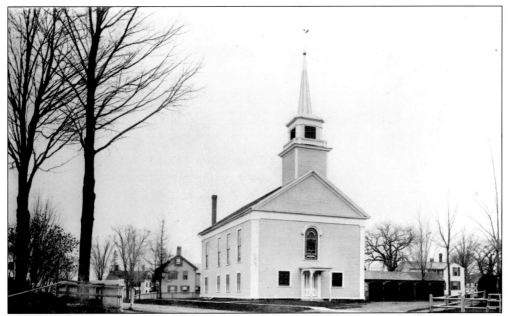

After the Richardson Tavern was moved and added on to the Groton Inn, the Baptist church was built on that site in 1841. Even earlier, the house of Gershom Hobart, an early minister to the town, occupied this site. The steeple has housed the official town clock, given by Samuel Green, since 1897.

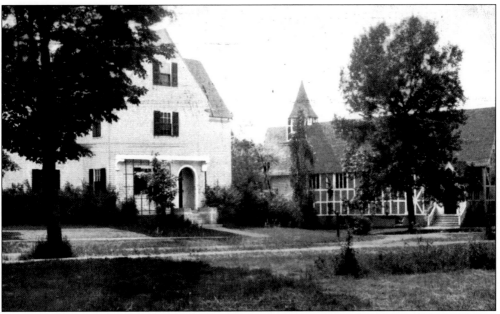

The Sacred Heart Church, pictured on the right, was built in 1887 as the Groton School Chapel. In 1904, the church was moved into town on rollers pulled by horses. The parsonage, originally built as a residence, stands to the left of the church. Church services ceased here in the 21st century, leaving St. James Church in West Groton the only Catholic church in town.

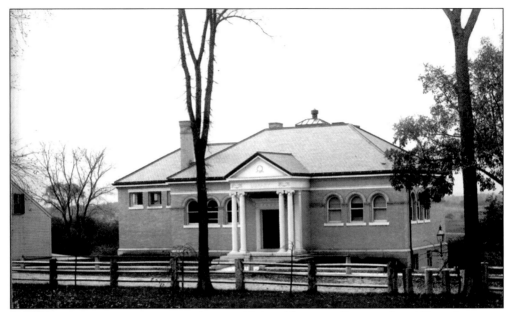

In 1854, a committee was appointed to establish a library in Groton after Abbott Lawrence gave $500 to the town to further this cause. At this time, there were fewer than 20 libraries in Massachusetts. Groton's library started out in a private home and moved several times before returning to the town hall in 1876, where the book inventory grew to 2,500 volumes. In 1888, Charlotte Sibley gave land and lent money to build a permanent library building.

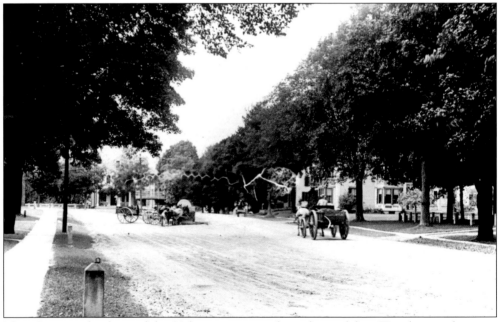

Main Street at the dawn of the 20th century was a busy thoroughfare. Travelers on their way to Keene, New Hampshire, passed through the center, often staying in one of the inns on Main Street. This road also went to Concord and on to Boston. The drinking fountain in the middle of the street was constructed for horses to drink from while carrying their passengers to their destinations.

During the 18th and 19th centuries, families kept fire buckets in the home. Most homes owned two leather buckets, often numbered and decorated with paint. These buckets were used in the home in case of a fire but were also used in community firefighting. Before organized fire departments, local men joined together with their buckets, carrying water, snow, or sand to extinguish a fire.

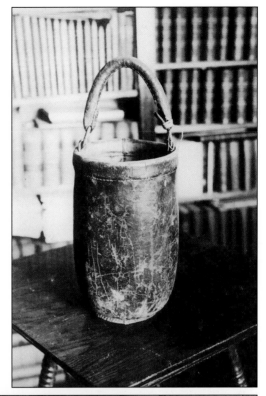

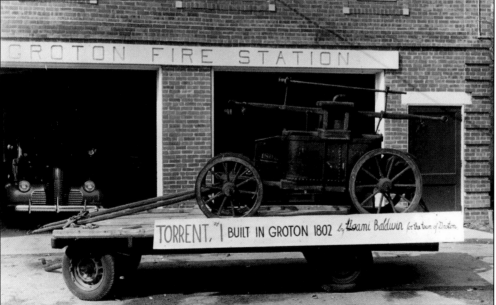

In 1802, Loammi Baldwin Jr. invented the town's first firefighting apparatus. He noted the inefficiency of controlling large fires with nothing but a line of men carrying leather fire buckets. Torrent No. 1, as it was called, was a horse-drawn water pump built in local shops and was used for almost 100 years. Firefighting equipment was later kept behind the town hall. In 1940, the Odd Fellows Hall at the center of town was turned into a fire station.

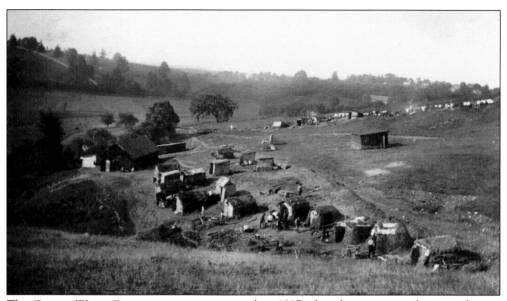

The Groton Water Company was incorporated in 1897 after the town raised issues of water supply and a system for distributing water. Despite the town's concern, only a few individuals came forward to make the water company a reality. This photograph shows Gibbet Hill with temporary living quarters for unmarried workers brought from Boston to build the water line. The water was turned on in December 1897.

All bills due on or before the 10th of the month.

Office on Station Avenue. Office Hours from 9 A. M. to 12 M .and 1 P. M. to 5 P. M. on the 5th and 10th days of the month in which bills are rendered. Not open any evening.

If the above dates fall on Sunday or a Legal Holiday, the office will be open on the following day.

☞ Where bills remain unpaid for 60 days, current may be shut off without further notice.

Make Checks payable to Town of Groton Electric Light Commission.

Groton, Mass., ___ JUL 1 1930

Mr. Howard L. Gilson

To TOWN OF GROTON
ELECTRIC LIGHT COMMISSION, Dr.

MAY JUN

For Electric Current furnished in the months of ___

Lighting $.075 per K.W.H.	1c discount per K. W. H. for lighting if paid within 10 days from date of bill.	61	K. W. H. @ $.075 Min.	4	58
			Discount on lighting		61
Present meter reading 3681 K. W. H.			Net lighting	3	97
Previous " " 3620 K. W. H.			K. W. H. @ $.03 Min.		
Difference 61 K. W. H.			Total Power		
Power $.03 per K. W. H. NO DISCOUNT			Balance due on previous bill not subject to discount		
Present meter reading ___ K. W. H.					
Previous " " ___ K. W. H.			*Total amount due*		
Difference ___ K. W. H.					

Received payment for the Town

Pd. by check 2462 July 7, 1930

No Discount allowed for lighting unless bill is paid in full.

Minimum By-Monthly charge for Lighting $1.50

Minimum By-Monthly charge for Power $1.50 per K. W. of demand

Your demand is ___ K. W.

Customers who desire, for any reason, to discontinue the use of the current, must give prompt notice in writing to the Commission to remove the meter as otherwise they will be held liable for the subsequent service.

OVER

In 1909, electricity was chosen as the desired power source for the town. Construction of a power plant began the next year along with the erection of telephone poles, and on November 20 of the same year, the streets of Groton were lit up along with several businesses and homes.

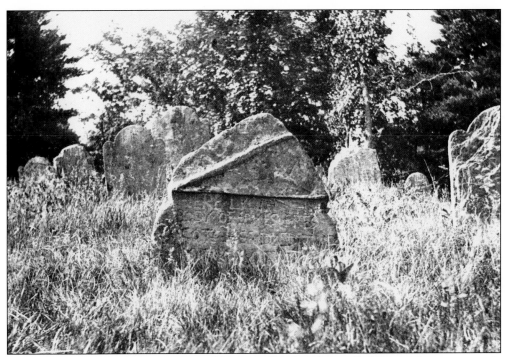

The old burying ground is near the site of the second meetinghouse. Before town burying grounds were built, people were often buried at their homesteads. The oldest headstone still standing in Groton is dated May 19, 1704, and belongs to James Prescott, who died at the age of 20.

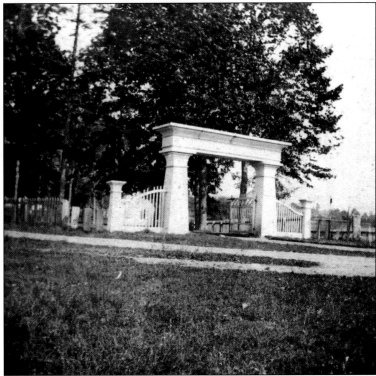

A new cemetery was built in Groton in 1847. An arch and a fence marked the main entrance until the early 20th century, when a stone gateway was gifted by John Gilson. Many well-known citizens from Groton are buried here, including George Boutwell, Endicott Peabody, Caleb Butler, and Samuel Green.

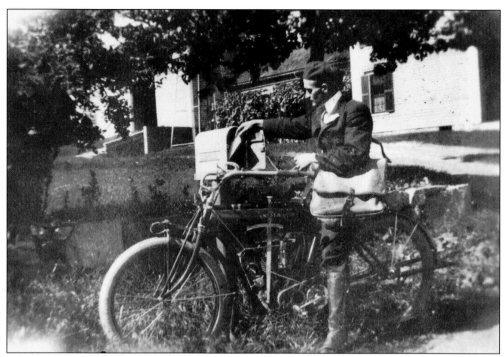

Howard L. Gilson was the first mail carrier in town for the rural free delivery service. He delivered mail in Groton from 1905 to 1935. When he first started the job, he used a horse and carriage to get around Groton. His Indian motorbike later proved a more efficient run of the route. (Courtesy of Martha Gilson.)

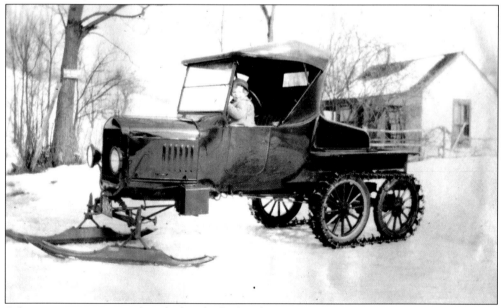

Gilson was even equipped to deal with the harsh winters. His 1924 Model T Ford truck was altered during the winter season to traverse the roads in snow. Gilson attached skis to the front of the truck in place of wheels and the back treads were outfitted with heavy chains so he could still make his mail deliveries regardless of weather conditions. (Courtesy of Martha Gilson.)

Seven

DOING BUSINESS

During the 19th century, industry in Groton boomed with the advent of the railroad, as did most surrounding towns. Small mills gave way to larger companies employing many workers. Mills were certainly not the only industry in town. As was true elsewhere, small stores, bakeries, and shops were important in sustaining families and economic balance in Groton. Looking up Main Street in this photograph, Gerrish's store is visible on the left.

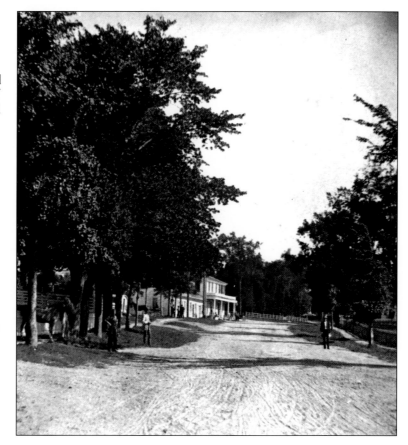

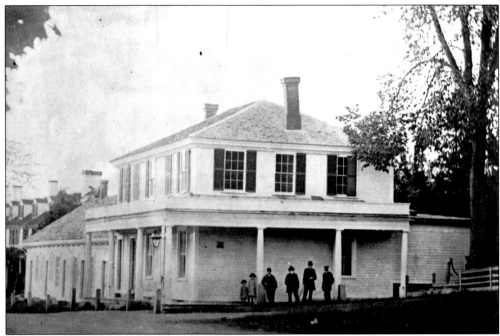

This building was constructed in the 1780s at the corner of Main Street and Lowell Road. The first floor was used as a general store, and the second floor served as a meeting space for various groups and school classes. At one point, the post office was located here, and Caleb Butler offered books that one could borrow for just a few cents a week. Charles Gerrish took over the store around 1850 and ran it until it was moved to Hollis Street in 1885.

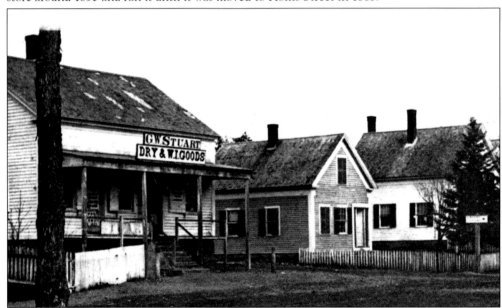

G. W. Stuart's store was built in 1851 in Groton Junction and was the first in the area. He sold a wide variety of general goods. This building was later moved farther back on Washington Street to make room for his new store. The older building was used as a drug and jewelry store by E. A. Markham and Dr. Ebenezer Willis. Stuart lived on the top floor of his old store building.

The building, known as the Dix or Southard house, was built in several different parts. The main brick house is the older part of the building, constructed around 1773. The long addition was used for sheds, and the upper floor housed several lawyers' offices. The building was already being used as a store when Benjamin P. Dix purchased it in 1825.

This advertisement for Dix's store ran in local papers of which Groton had several. The image on the advertisement is an etching or engraving of the actual building. And the goods mentioned reflect many country stores of the 19th century: most did not specialize in a particular good or service but offered a variety like the Dix store, which, at this time, dealt in paints, medicines, and shoes.

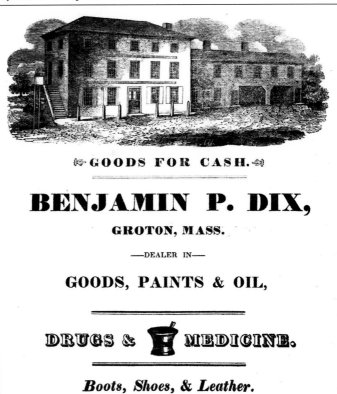

GOODS FOR CASH.

BENJAMIN P. DIX,

GROTON, MASS.

—DEALER IN—

GOODS, PAINTS & OIL,

DRUGS & MEDICINE.

Boots, Shoes, & Leather.

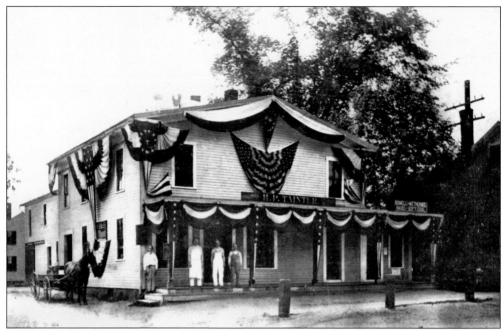

Harry Tainter ran the H. P. Tainter Store, which was located at the corner of Main and Court Streets. The store was like others in town in that it carried necessities like groceries and tools. In the back of Tainter's store, however, was a bakery, which set it apart from other small stores. Every day, Tainter's was able to offer fresh baked goods to customers. In this photograph, the store is decorated with bunting for a celebration.

Bruce's pharmacy opened next to Butler High School in 1881. William Bruce was the owner, and the store stayed in the family after he was gone. He and his wife moved to Groton from Acton with the purpose of establishing a pharmacy business in town. In fact, it was the only pharmacy in town for over 40 years. In this photograph, the pharmacy is decorated with bunting in celebration of Groton's 250th anniversary.

This brick building is an iconic structure along Main Street. Henry Woods built it in 1835. There, he and George Boutwell kept a store together, which sold general goods. In the early 20th century, John Sheedy purchased the building for use as a grocery store before he died in 1923. The Groton Post Office relocated to this building in 1943, where it remained for many years.

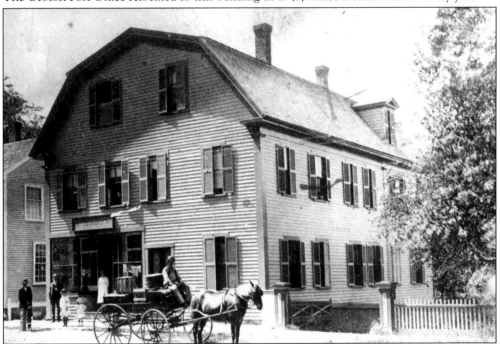

Moore's store was located across the street from the Boutwell and Woods store. It offered general goods and "gents furnishings," which were accessories, clothes, and shoes. There was a beauty shop in the rear of the building, and the post office was located there for a time. In this photograph, the building has a gambrel roof and was later altered to a much different look.

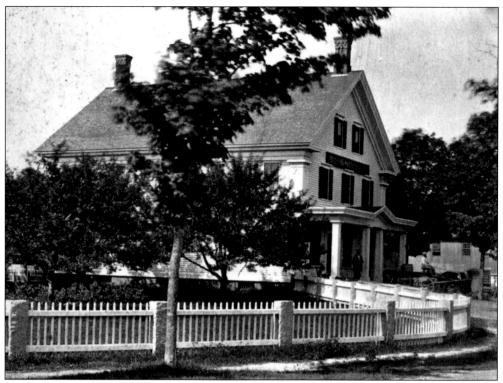

During the mid-19th century, Milo Shattuck built a hardware and grocery store. He constructed it so that its side faced the street, but, because of a curve in the road, everyone traveling up Main Street had the front of the shop in view. In 1955, the building was given a quarter turn to face Main Street.

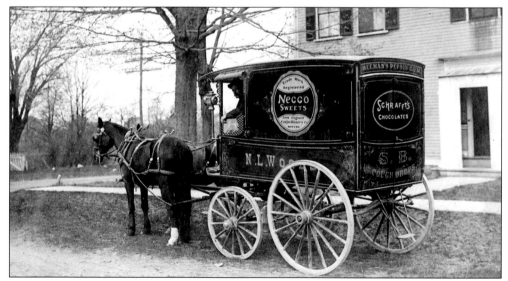

Nesbit L. Woods rode in this horse-drawn carriage when he was in the business of selling wholesale candy. Woods delivered his goods to stores in Groton, Westford, Chelmsford, Littleton, Pepperell, and Townsend. This photograph was taken on Main Street in 1905. After Woods ceased using this wagon, it was converted into a barge to transport children to school.

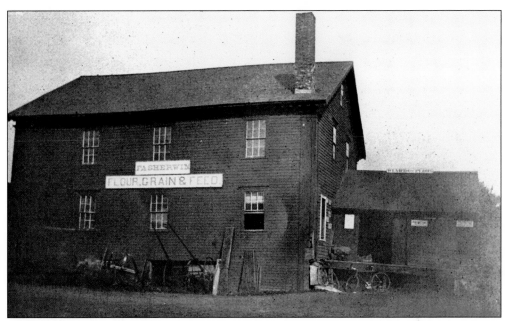

Frederick A. Sherwin's store was located near the train depot at the center of Groton. The store sold not only grain and feed but also some larger farm implements. The 1906–1907 annual report of the town shows that the poor farm purchased $220.79 worth of supplies from his store. He was also paid for "teaming," which may mean he supplied, for work, both animals and the implement to which they were harnessed.

According to this receipt, Augustus Woods purchased hay, oats, and other items for use on his farm. The 1903 receipt carries a list of the types of goods for sale in the shop, including poultry supplies. During the early years of the 20th century, Groton still had prosperous farms, despite new industry in town, so a store of such type was still necessary.

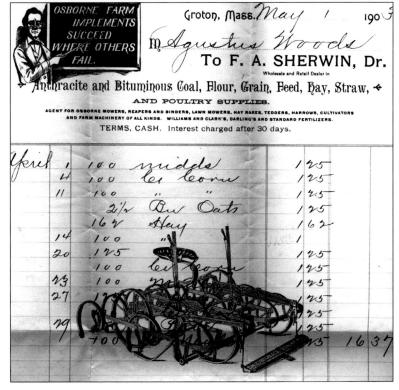

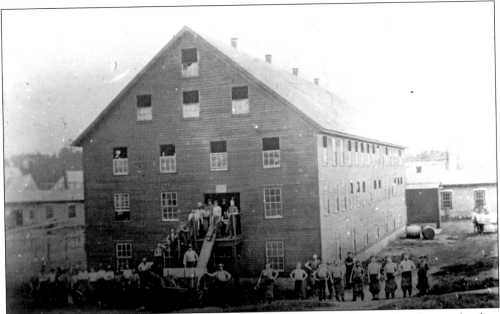

This tannery at Groton Junction was established in 1854. For the first couple of years, the shop only did tanning. After that, the second floor was used as a currying and finishing shop before a new structure was built for that purpose. It was a long running and successful business.

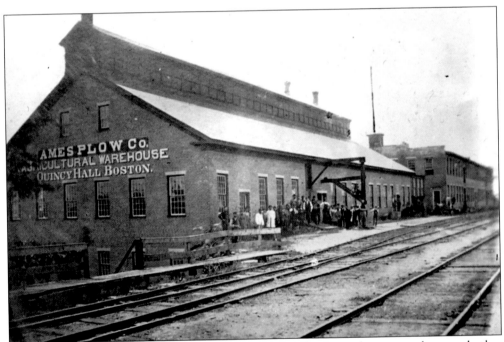

This building was erected in 1850 as a facility for manufacturing plow parts, plows, and other agricultural tools. The business was sold to a number of different people before Oliver Ames purchased it in 1864 and it became a branch of the Ames Plow Company, operating until 1875. Another branch was located at Quincy Hall in Boston.

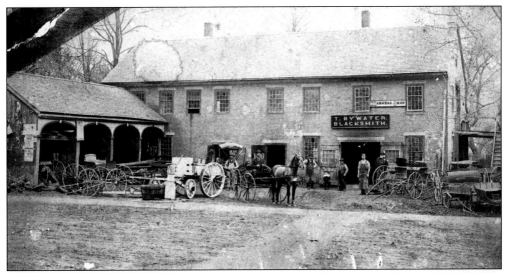

Blacksmith shops dotted 19th-century New England towns. Some blacksmiths produced tools and machinery, others made repairs, and some dealt exclusively with shoeing horses. Most common, however, was a village blacksmith who performed general work, both building and repairing, as needed by customers. The Bywater Blacksmith shop was built around 1838. The number of horse carts at the building suggests that the blacksmith either did wagon repairs or that he also operated a livery stable.

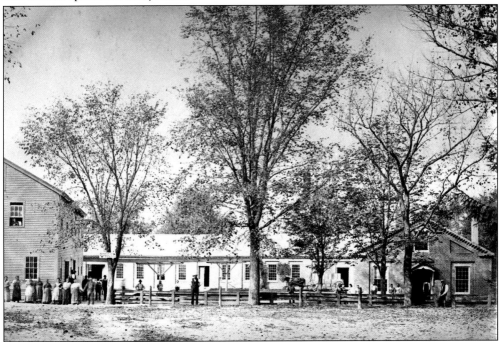

Several different mills were located on the Nashua River, where the road leading to Pepperell goes off. In the 18th century, there was a corn and sawmill at this location. During the 19th century, the mill was used first as a sawmill and gristmill before new buildings were constructed by the Hollingsworth Paper Mill. This may have been a branch of the Hollingsworth Mill in West Groton.

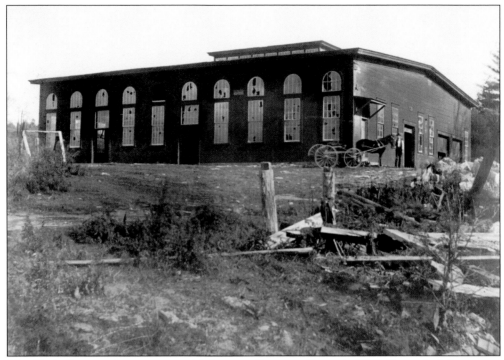

John Fitch discovered soapstone on his farm on Common Street in 1828. He worked the quarry by hand, and over the years, several buildings were erected to facilitate the harvesting of the soapstone, but all were burned. Around 1865, the Groton Soapstone Company constructed a new building with the conveniences of modern machinery.

GROTON
SOAPSTONE QUARRY.

ALL ORDERS FOR
Blocks, Slabs, Register and Funnel Safes, Factory Rolls, Soapstone Stoves,

And all other Soapstone Work, will be promptly answered, and delivered on the Worcester and Nashua Railroad, by addressing

BIXBY & McCAINE,
PROPRIETORS,
n1tf *GROTON CENTRE, MASS.*

The Groton Soapstone Company quarry advertised in local papers. The *Railroad Mercury*, a newspaper printed in Groton Junction every Thursday evening, ran this advertisement in the October 6, 1859, issue. Soapstone is a soft stone, and one of its most popular household uses was in the construction of stoves and sinks. Soapstone could also be used to make bed warmers—slabs of stone heated by the fire and placed between the sheets.

Eight

WEST GROTON

Many towns grow up with several distinct villages in their bounds. West Groton is one of these villages with its own character, industry, and stories. With the Squannacook River flowing through it, it was natural that mills cropped up along the banks. Pictured above is the dam at the paper mill.

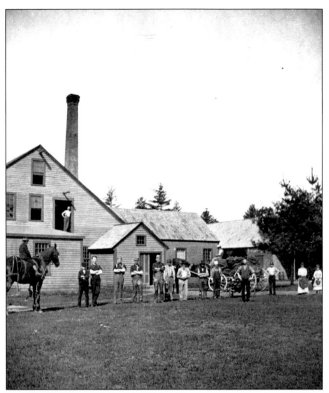

The Hollingsworth Mill in West Groton was established in 1852 on the site of an earlier mill on the Squannacook River. The mill originally produced paper from jute and manila fiber. In 1881, the name of the operation was changed to Hollingsworth and Vose. This mill has been in continuous operation since it opened.

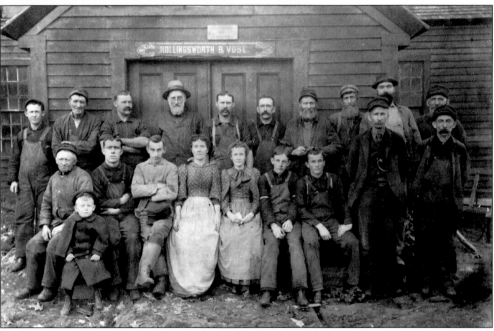

Here a group of Hollingsworth and Vose workers pose outside the mill. Mills had various jobs available and the workers here are a variety of different ages, both men and women. Most workers lived in the immediate area and were dedicated workers for many years. Oftentimes worker housing was set up in small buildings by the river.

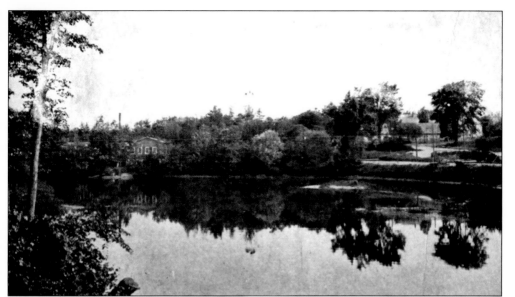

About a mile above the Hollingsworth and Vose mill on the Squannacook River in West Groton was the A. H. Thompson Mill. When Asa Howard Thompson purchased the mill around 1885, he built an addition and began to manufacture new products such as boxes and wooden reels. The mill remained in operation until 1966.

Thompson came to West Groton around 1883. He lived in the village, worked at the mill, and had a knack for inventing equipment to make the mill run more efficiently. One of his patents, dated December 8, 1903, illustrates a "machine for manufacturing leather board or similar material."

No. 746,404.　　　　　　　　　　PATENTED DEC. 8, 1903.

A. H. THOMPSON.

MACHINE FOR MANUFACTURING LEATHER BOARD OR SIMILAR MATERIAL.

APPLICATION FILED SEPT. 23, 1903.

NO MODEL.

Fig. 2.

Fig. 1.

Witnesses.

Lehaun B. Choate

Wallace L Bumie

Inventor.

Asa H. Thompson.

by N. C. Lombard

Attorney.

95

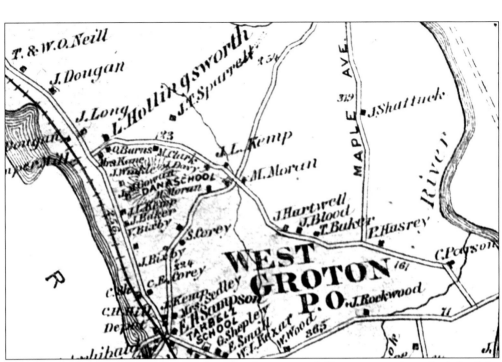

The village of West Groton is situated on the Squannacook River, pictured on the left of the map. This detail of a map of West Groton shows familiar names and places. Schools, mills, and residences are listed. The depot is marked where all three roads to the village converge.

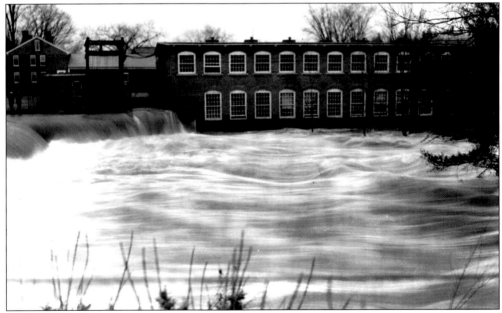

The Groton Leatherboard Company established business in a mill on the Squannacook River in West Groton and was incorporated in 1899. It ran continuously until 1914 when the building was destroyed by fire. A more modern structure was built of brick, which was thought to be fire resistant, and business resumed in 1916. The company operated until 1970, when it closed permanently. The mill has been rehabbed to house an assisted-living facility.

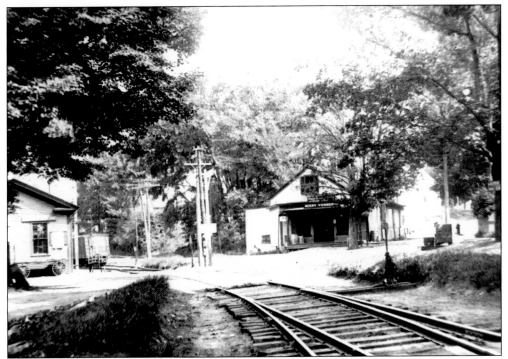

The West Groton line of the railroad was originally intended to go all the way to Peterborough, New Hampshire, but was built only to Greenville, New Hampshire, and became known as Boston and Maine Railroad's Greenville branch. Across from the train depot was a general store. Although it changed hands many times, it has always been a permanent fixture in the West Groton Square. (Courtesy of Ruth Rhonemus.)

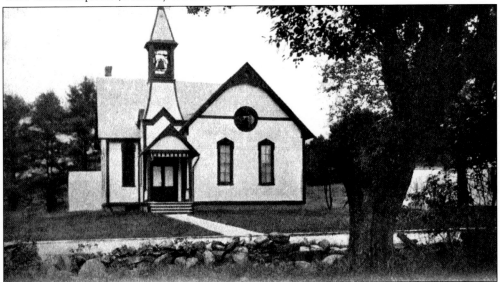

Public religious services began in West Groton in 1865, and for years, they were conducted in private homes. In 1885, work was completed on a building and the Christian Union Church was dedicated and opened to the public. This was the only church in West Groton until 1929, when St. James Church was built.

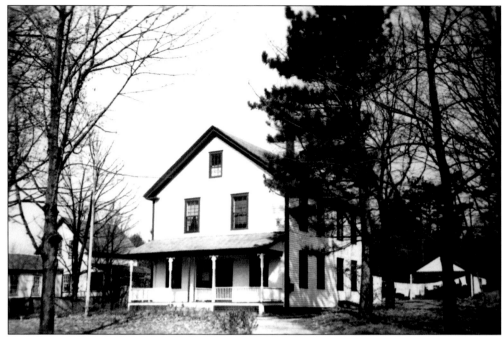

The first Tarbell School was built in West Groton in 1893. It was constructed as a district school. Since numbering district schools had fallen out of fashion, this one was given a name straight away. The Tarbells were a prominent West Groton family and one of the first proprietors of Groton. Edmund Tarbell, a well-known American impressionist, was born in West Groton in 1862.

In 1913, plans were approved to build a new elementary school in West Groton. This school was called the Tarbell School and took the place of the old Tarbell school that functioned as a district school. The funding approved to build the school fell short. An additional $4,900 was approved, which gave the building committee enough funds to construct a safe and secure school.

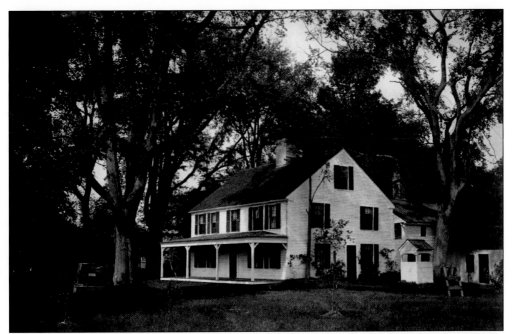

The Rockwood or Sedley house is located in West Groton and was likely built around the time of the American Revolution. Samuel Rockwood probably lived in this house but had brothers living in West Groton as well. Three of his brothers ran a carding mill on the Squannacook River. Rockwood died while serving as town clerk in 1804.

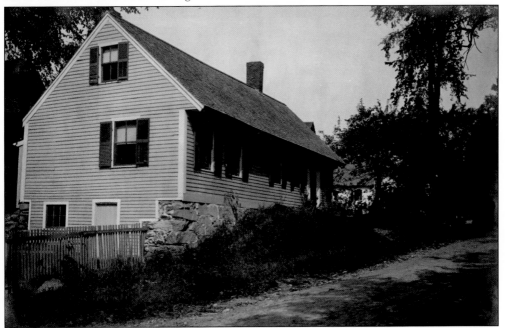

This house is on the road from the village of West Groton to Pepperell. Many old homes were built into hillsides to allow a walkout basement with plenty of space and easy access. Easy access was needed because the cool basement was often used as a root cellar to keep fruits, vegetables, and jars of jam.

This large brick residence is near the old leatherboard mill in West Groton. It is one of several brick houses in the town. When the first settlers arrived in New England, particularly rural areas, there was such an abundance of wood that it became the primary building material of houses. Those that were built of brick could be said to follow the European style of building more closely.

This advertisement ran in a Farmers and Mechanics Club informational brochure in the early 20th century. While the location is unknown, this pool room with bowling alleys must have been located either in a store building or in a portion of a large house. On the West Groton map, a Mrs. Kane, perhaps a relation to P. W. Kane, is listed as living on the road to Townsend.

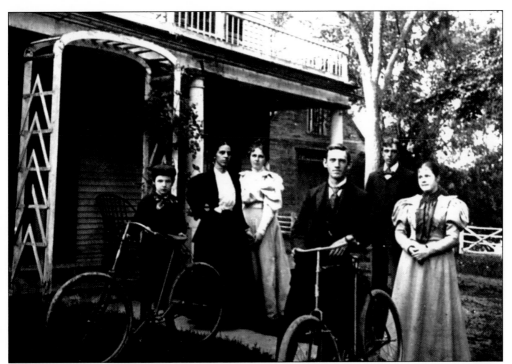

According to maps of Groton from the 19th and 20th centuries, there were several Hill residences in West Groton. Here members of the Hill family stand outside one of these homes. By the late 19th century, bike riding was a popular leisure activity. While only boys stand with bicycles in this photograph, women enjoyed riding as well, as it gave them the freedom to wear bloomers under shorter skirts to keep the fabric away from the spokes.

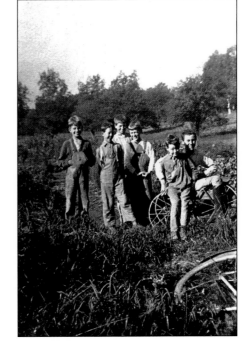

Elizabeth Hill lived at her house Willow Dell in West Groton. She planted gardens and also had a small tree farm. Her gardens were sometimes referred to as Scout gardens, as she had both Boy Scouts and Camp Fire Girls over often to work in the gardens. Here a group of Boy Scouts is pictured around 1913 on the Willow Dale property.

Nearly everyone in New England remembers or has heard of the flood of 1936. In March of that year, Massachusetts suffered through the worst flooding in its history. Groton suffered the same fate as many: bridges washed out and roads crumbled under feet of rushing water. Here the road to West Groton lies submerged.

Above is another view of West Groton in March 1936 near the center of the village. This photograph was taken after the floodwaters had subsided somewhat. The water is still quite high, nonetheless, as it flows over the mill dam. Cleanup and rebuilding after the flood took its toll emotionally and financially.

Nine

PASTIMES AND AMUSEMENTS

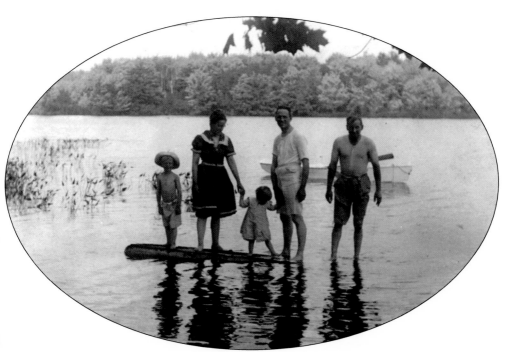

As is true now, life in earlier days of Groton was not all work and no play. When children were not at school, when men were not at work, and when women were done with chores, there was always time to enjoy celebrations, join community clubs, and partake in simple amusements. In this photograph, the Bennett family is enjoying the pleasures of everyday life, as they spend time at Baddacook Pond.

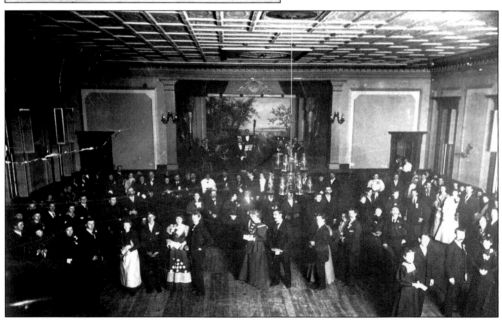

Groton Jan. 29th 1859

The ladies are much indebted to Mr Charles S. Park for his skill & kindness in teaching them to skate, & wish to express their thanks, by presenting him with a pair of Skates, which he will please Select, for himself.

From

Mary H. Nightingale
Augusta M. Warren
Mary H. Lawrence.
Minerva T. Warren
Fannie Lawrence
Abby E. Boutwell
Rux J. Waters.
Mary L. Warren.

This letter, dated 1859, was signed by eight young women thanking Charles Park for giving them skating lessons. To show their gratitude, they presented him with the opportunity to choose a pair of skates of his liking that they would purchase. Ice-skating was a popular activity for young girls in the 19th century because it was one that was acceptable for them to do with boys.

Each year, there was a fireman's ball that was much anticipated. This tradition started in the 19th century and continued on into the 20th century. There was music and dancing within the town hall until midnight, when a turkey dinner was served. The festivities then continued on until well into the morning. This 1894 photograph shows the band on stage and revelers enjoying the atmosphere at the 19th annual concert and ball.

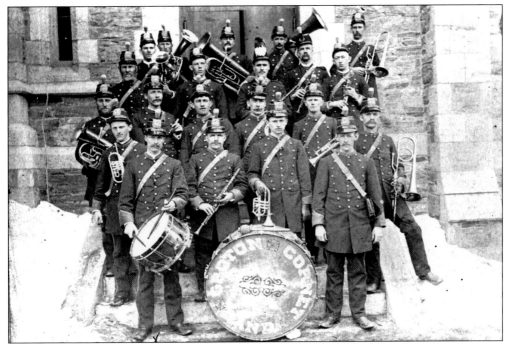

Town bands were organized to provide entertainment and music for parades and ceremonies. The Groton Cornet Band was established in 1856 by a group of 16 men living in town. The group hired a teacher from Nashua, New Hampshire, and began practicing immediately. They played in parades and at fairs and other celebrations until they disbanded in 1931. There were many men in the band who had faithfully played for over 50 years.

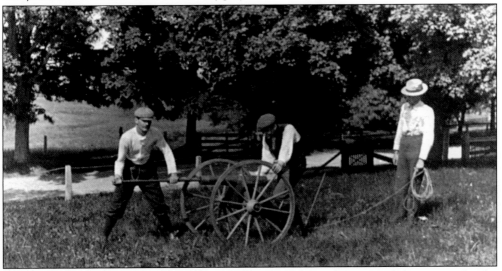

Here canons are prepared for firing during a Fourth of July celebration. Other events for the day included the following contests: the standing jump, the running jump, the 100-yard dash, a 3-legged race, a barrel race, a wheelbarrow race, the 220-yard dash, a greased pole, a tug-of-war, a bicycle race for ladies, a bicycle race for men, a greased pig, and a baseball game. Prizes were awarded for each, and the only condition for entering was "all contestants must be residents of Groton."

The Appalachian Club was formed in 1876 to promote the appreciation of the mountains, rivers, lakes, and forests of the Appalachian region. A club chapter proposed to visit Groton in 1886 and view the landscape that the town had to offer. This early-20th-century photograph is labeled, "Appalachian Club in Groton" and may depict another such excursion to Groton.

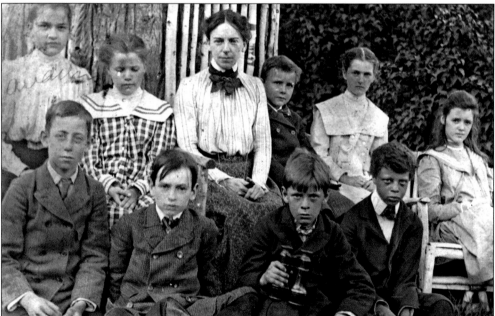

Audubon societies focus on the appreciation of birds, other wildlife, and the habitat in which they live. In Samuel Green's *The Natural History and the Topography of Groton, Massachusetts*, there is a list of bird species seen in Groton and the declaration, "Mr. Ralph Hoffmann, a well-known ornithologist, said that the Groton Audubon Society was the liveliest and know the most bird lore of any society in the State."

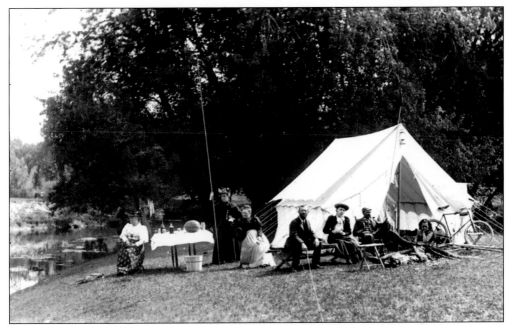

This 1894 photograph shows the Wright family camping by the Nashua River. William Wright (center) was a photographer, and the cable he is holding in his hand may have allowed him to be the photographer while posing with his family. The woman standing by the table is holding a fishing rod probably made many years earlier. Early rods were long and did not have reels.

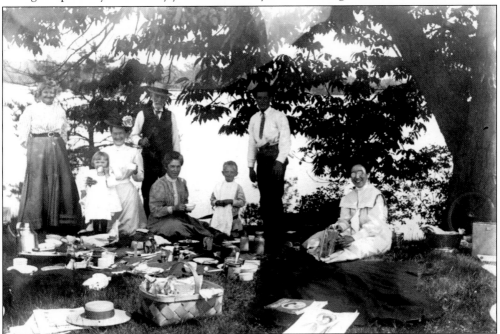

Family picnics at Baddacook Pond were a popular pastime for the Bennetts. Picnics were once fashionable social gatherings, where each person contributed food. Now they are a much more casual and relaxing affair. Based on the items scattered around them, the family spread out blankets to enjoy lunch and relax with magazines and maybe take a canoe ride.

A common social get together in the late 19th century, lawn parties were usually casual picnics with outdoor games. Attendees to these parties were mostly neighbors in the immediate area, which often included many family members. This party was held on the lawn of Henry Bancroft's house, located on Powder House Road.

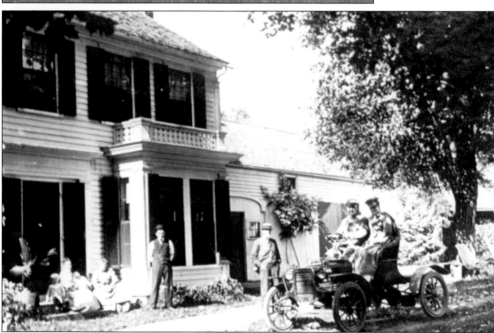

This 1905 photograph was captioned, "Motoring in Groton in 1905." Indeed in 1905, it was still a rare sight to see a car puttering down Main Street, especially before the roads were paved. Mark Blood was said to have one of the first automobiles in town, which was purchased in 1903.

During the right season and at the right viewing location, Mount Monadnock in Jaffrey, New Hampshire, is visible from Groton. Once cars became more readily available, taking a day trip to the mountain and other destinations was much more feasible. Pictured here are gentlemen resting at the summit of Mount Monadnock.

This formal portrait shows Mrs. Duncan dressed in mountain climbing gear and posed with a walking stick. Photography studios in the late 19th century allowed customers to choose their background, props, and clothing to achieve a certain look. Just as artists often portrayed their subjects holding items that hint at the person's hobby or profession, photographers could do the same. Therefore, it is quite possible that Duncan enjoyed hiking outdoors but not necessarily in this particular garb.

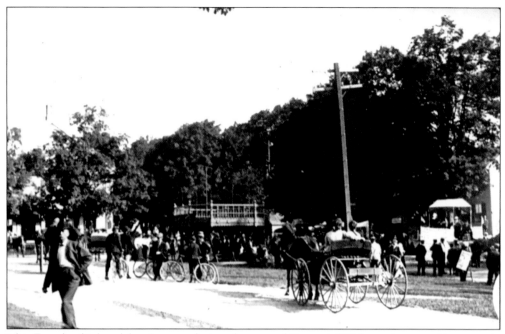

This Fourth of July celebration was during the year of Groton's 250th anniversary. Here people crowd around the common to socialize and enjoy music. The wooden bandstand was built in 1882 and was originally located on the grounds of Butler High School. It was later moved to the small common in front of Shattuck's Store, seen here. It was replaced in 1917 and eventually taken down.

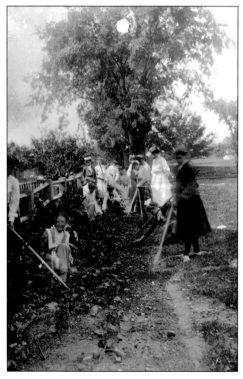

The Village Improvement Society was formed in 1902 to make positive changes to the schools and communities. The most noticeable of these improvements were gardens planted and tended to by schoolchildren, under supervision. There were several gardens around town that they maintained, and the society's accomplishments were noted in the town reports.

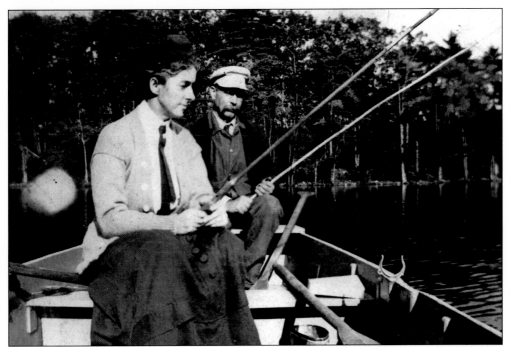

The ponds, lakes, and rivers that are so abundant in Groton were not just for swimming and skating. Fishing for sport became a popular pastime in the late 19th and early 20th centuries. According to Samuel Green, salmon was caught on at least one occasion in Groton. Baddacook Pond was stocked with trout, and all the waterways in town contained smaller, more common species of fish.

Fishing was not relegated to just a summer activity. William P. Wharton drilled through the ice and set up his ice-fishing gear and equipment. Since he spent much time near Baddacook Pond, it is reasonable to assume this is where he chose to fish. As he stood back to take this photograph, he caught an expansive farmhouse and barn in the back of the composition.

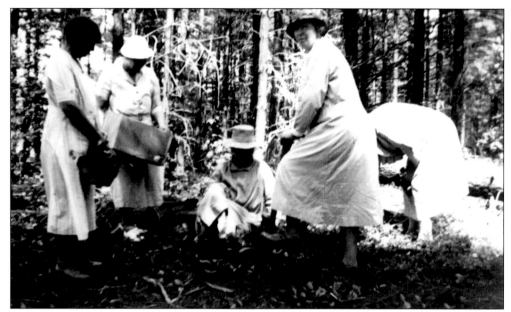

Groton's garden club was founded by Elizabeth Wiggin Wharton in 1923. Wharton was a Lowthorpe School graduate in the class of 1922. She was married to William P. Wharton, and together they raised awareness of both birds and plants around Groton. This 1936 photograph shows the garden club planting lady slippers in the town forest.

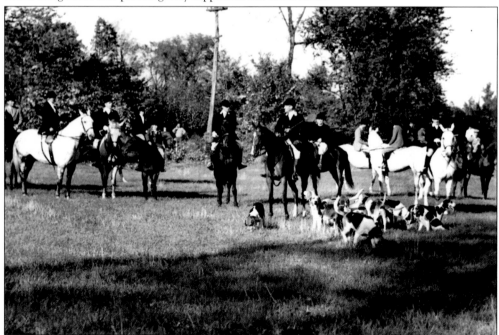

Master of the foxhounds, Richard Danielson (center) organized the Groton Hunt Club in 1922. He kept all horses, foxes, and hounds on his property. The trails that the riders followed wound through Groton and neighboring towns. Hunts were held numerous times a week during the season, but the annual Thanksgiving Day hunt was the most anticipated, and it was always followed by a formal ball. (Courtesy of Zoë Eleftherio.)

Ten

LOST SITES

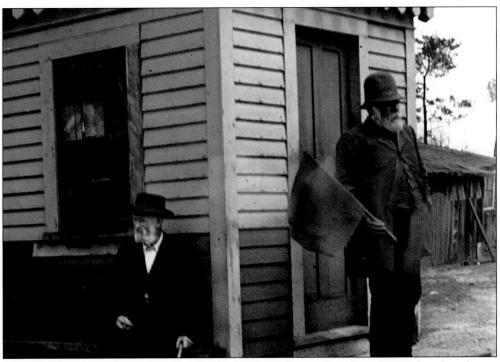

Meant to be permanent structures, many buildings in Groton have been lost to fire, demolition, and the ravages of time. In other cases, changing boundary lines have caused buildings to reside in a new town. This signalman's shack was on Main Street in Groton Junction. John Flanagan (seated) lived across the street from this shack. He signaled traffic when trains came through the junction.

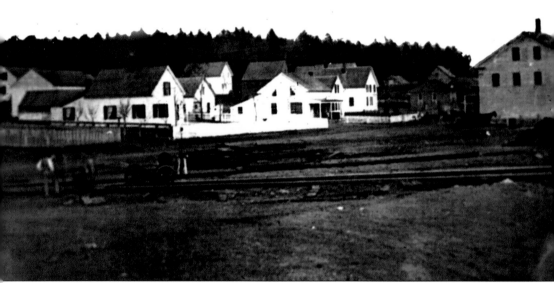

The area now known as Ayer was once called South Groton. The area was originally one large land grant given to Maj. Simon Willard and was called Nonaicoicus. The land was eventually divided up into smaller plots, but few people lived in this quiet area, and only two roads ran from Groton Center to South Groton. The railroad came to South Groton in 1844, and after a few years, several railroad lines met here, including one from Boston to Fitchburg, one from Townsend to Peterborough, New Hampshire, and one from Worcester to Nashua, New Hampshire. Then the village became known as Groton Junction. This view from about 1855 of Groton Junction shows new buildings that sprung up as the railroad brought more people and business to the area. In the foreground are tracks of the Worcester and Nashua Railroad. District school number 12 can also be seen towards the right. It was torn down soon after the photograph was taken.

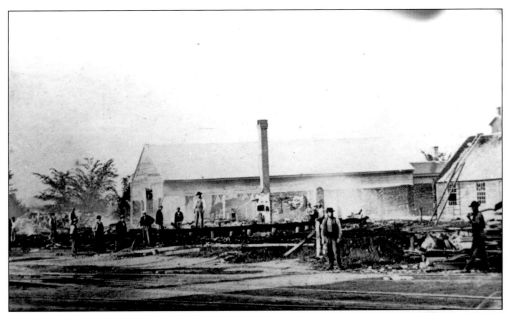

A fire on July 15, 1870, destroyed Merchant's Row in Groton Junction, starting out in a hotel stable. The entire row, except for one house, was burned to the ground. The railroad depot caught on fire several times as the blaze burned but was extinguished by continued efforts of the railroad employees. Very few of the original businesses came back to rebuild on this block.

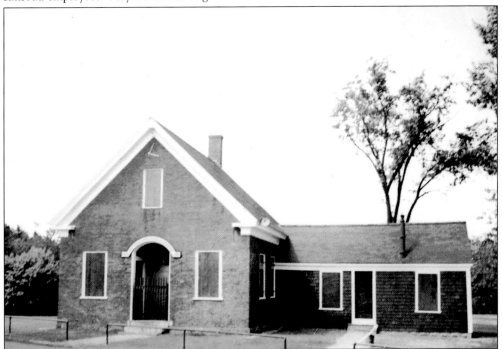

South Groton had two one-room schoolhouses, district numbers 11 and 12. The first district 11 school was built in the late 18th century and sold at auction in 1806. There were several other school buildings erected on the site before this was constructed in 1870. The school was later named the Sandy Pond School and is still standing in Ayer.

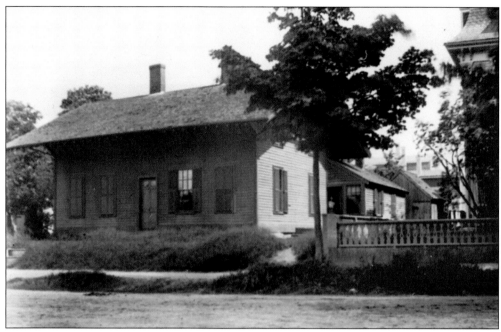

The first railroad that was built into South Groton was the Fitchburg line. The first station erected was a small building that stood on the south side of the railroad. When the Worcester and Nashua Railroad was constructed over the first sets of tracks, this station was moved onto Main Street, where it was altered and converted into a house.

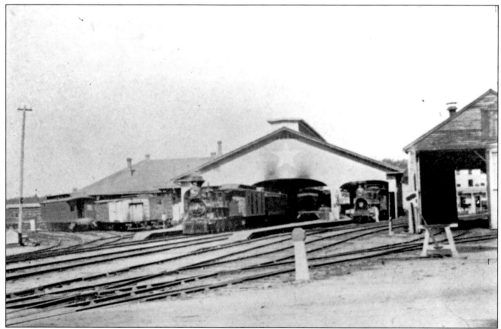

This photograph was taken several years after Ayer broke away from Groton. Over both the eastbound and westbound railroad tracks was a large train shed. The roof was initially held up by large iron columns, which were removed in 1871, the year the station ceased being within the bounds of Groton.

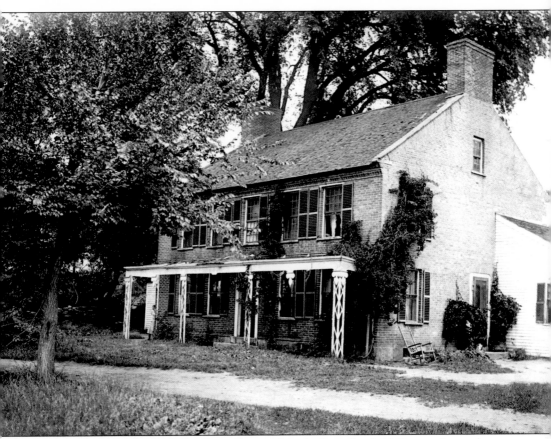

This residence is the oldest brick house standing within the bounds of old Groton. It stands on what is now Park Street in Ayer, where generations of the Park family lived. John Park (1723–1793), a stonecutter, was killed in 1793 in an accident involving a large stone while building a jail in Amherst, New Hampshire. It was either he or his son John who built this house in South Groton in 1791. A slate slab is set into the brick at one corner inscribed with "JP" and the date. The Park family suffered another tragedy when John G. Park was killed in the same area of Groton in 1848 by a train as he crossed the Fitchburg railroad tracks. He was 60 years old at the time and was killed instantly.

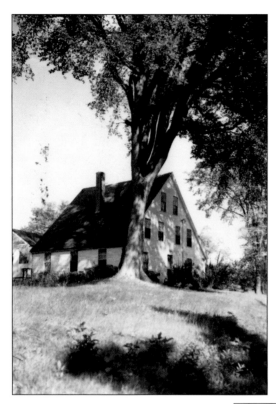

The House of the Long Roof, or the Ascension House, stood on Farmer's Row near Culver Hill. The steeply pitched roof was unique in town, as was its mid-19th-century use. In 1844, a group of Millerites dressed in white robes climbed onto the roof of the Ascension House and waited for the Second Advent.

Henry Woods owned this house, which was by the brick store on Main Street that he operated with partner George Boutwell. For several years, Boutwell and his wife lived with the Woods family, and both the Boutwell children were born in the house. The structure was destroyed by fire in the early 1890s, and a new house was moved to this location.

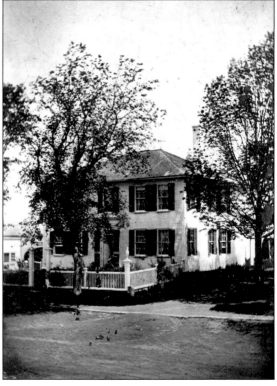

The Groton Hospital was set up by Dr. Arthur Kilbourn in the early years of the 20th century in a home he purchased on Main Street and then renovated. This spacious house accommodated 25 beds plus a small number of cots that could be used as needed. In 1910, Kilbourn installed an elevator operated with a pulley system in the building, making the second floor more easily accessible.

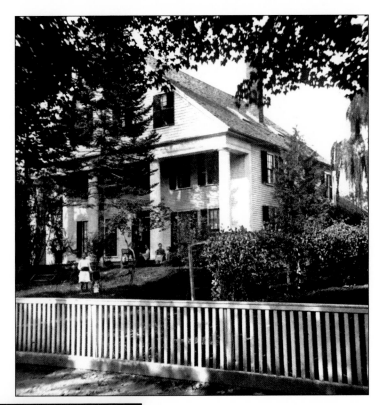

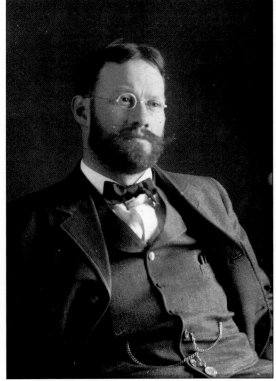

Kilbourn came to Groton in 1904 after graduating from Harvard Medical School. He performed his first operation in Groton in 1905 at a private home, which was customary for the day if no proper medical facility existed. After years of performing surgeries and other treatments in homes, Kilbourn recognized the need for a facility offering more room and better equipment, so he moved to the house he later turned into the Groton Hospital.

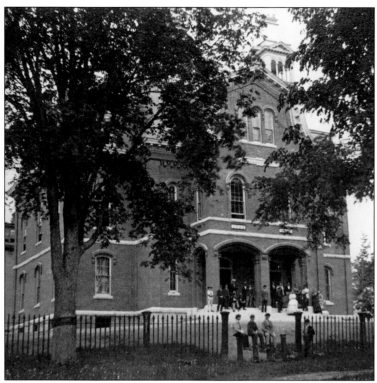

This brick building, which burned down in 1956, was constructed in 1871 at Lawrence Academy and housed a library decorated with a portrait of Caleb Butler and busts of Amos and William Lawrence. This building stood on the site of the original wooden school structure, which burned in 1868. There were serious suspicions that the fire was started by the son of the preceptor with firecrackers thrown onto the roof.

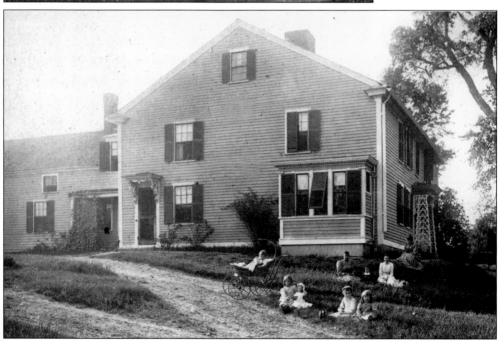

Built by John Longley around 1712, the Higley house stood near the Groton School. The Longleys inhabited most of the houses on that road in the early days of the town. At some point, the school purchased this house before it was torn down. Houses were most often torn down if there was serious structural damage caused by fires or a shifting foundation.

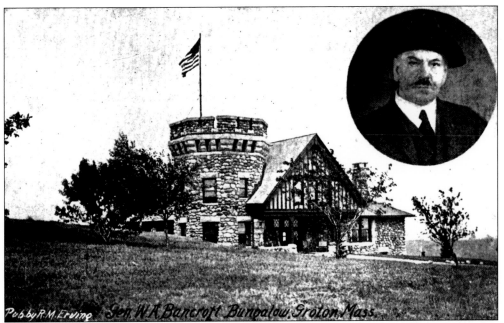

William Bancroft was born in Groton and returned to town at the dawn of the 20th century after years of military and political work. He had plans to build an expansive estate called Shawfieldmont atop Gibbet Hill. He built this house with stone as part of his planned estate; however, Shawfieldmont was never finished. Bancroft abruptly left town and left the house empty.

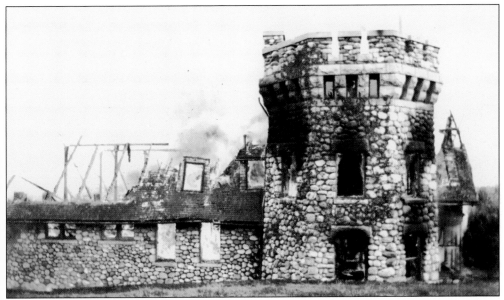

On July 4, 1930, the stone house that Bancroft built on Gibbet Hill caught fire, burned, and was largely destroyed. The ruins of the tower are still visible on the hill, and the large stone gate that Bancroft constructed to mark the entrance to his estate still stands on Main Street.

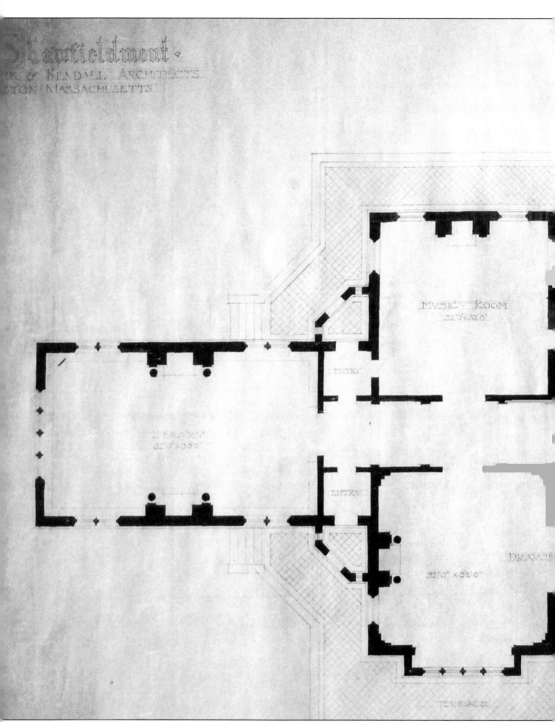

The plans of the castle that William Bancroft hoped to build as part of his estate on Gibbet Hill detail a large two-story manor with many rooms dedicated to entertaining. According to the plans drawn up by Park and Kendall Architects of Boston, the majority of the first floor was to be taken up by the drawing rooms, where Bancroft could no doubt entertain large parties. The

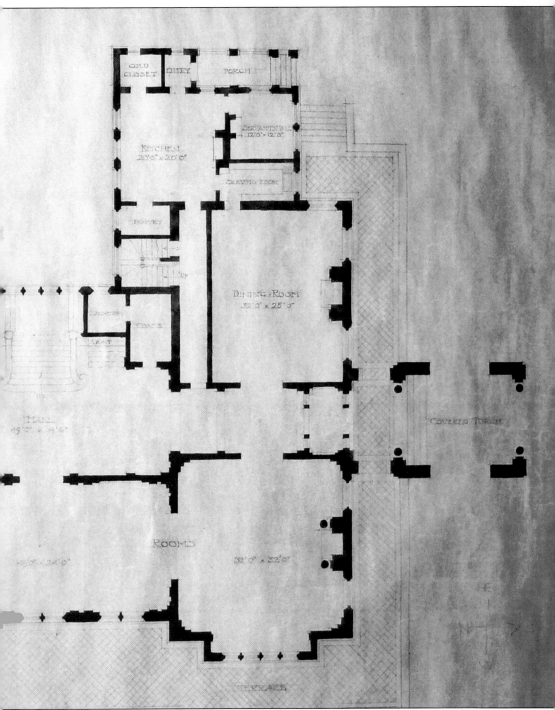

library that is planned at the left of the building utilizes both the first and second floors. On both floors, outdoor space is created with covered and exposed terraces, balconies, and porches. The plans show the second floor was to be used primarily for bedrooms. Between two proposed wings upstairs, Bancroft's castle would have had 14 bedrooms and eight bathrooms.

MAY-4-1921.	COUGH.	EXPECT.	APPETITE	SLEEP.
SAMPSON.	? NONE.	$\zeta \overline{55}$	P.GOOD.	ALL RIGHT
FOOT.	NONE.	$\zeta \overline{55}$	P.GOOD.	ALL RIGHT
TRICKETT.				
SHEA.	+++	$\zeta \overline{ii}$	GOOD.	P.GOOD.
LEONARD.	++	$\zeta \overline{T}$	GOOD.	.GOOD
REDFERN.	+++	$\zeta \overline{T}-$	GOOD.	P.GOOD.
BLAKE	PRACTICALLY NONE.	$\zeta \overline{ii}$	POOR.	GOOD.
DEAN				
EMERY				
O'CONNELL	NOT MUCH.	$\zeta \overline{ii}$	GOOD,	GOOD
GERARD.				
LAMPHIER.	++++			POORLY.
BANNON.	+ +++	MORE.	FAIR	ALL RIGHT
CUMMINGS.	LESS	$\zeta \overline{i55}$	ALL RIGHT	FAIR
WALLACE.	SAME.	$\zeta \overline{iii}$	GOOD.	FINE.
KELLEY.	L. BETTER.	$\zeta \overline{T}$	FINE	FINE
DANDREA.				
MABIE.	NOT VERY MUCH.	$\zeta \overline{55}$	ALL RIGHT.	ALL RIGHT
McKAY				
HUNTER.	NO.	NONE.	GOOD,	GOOD.
LEUCACEWITZ.	MORE.	$\zeta \overline{iii}$	FAIR	GOOD.
SAWYER	NO			
FI-LONDON				
SMITH	LITTLE.	$\zeta \overline{55}$	GOOD.	GOOD.
CAMPBELL.	LITTLE	$\zeta \overline{55}$	GOOD.	GOOD,
NASH	+++	$\zeta \overline{55}$	GOOD,	GOOD,
JALIENSKI	+ +++	$\zeta \overline{ii}$	FAIR	POOR.
BISAZZA	SAME	$\zeta \overline{iii}$	GOOD.	FAIR.
KIMBALL	SL.	$\zeta \overline{ii}$	VERY GOOD.	FINE
McEWAN	LITTLE.	LITTLE	GOOD.	GOOD.
PONTARELLI.	SAME	$\zeta \overline{ii}$	ALL RIGHT.	ALL RIGHT
LEE	+++	$\zeta \overline{iii}$	FAIR.	ALL RIGHT TO FAIR

AMT. H₂O CONSUMED	T. & P.	COMPLAINTS	REMARKS
			OFF. EXAM.
3 GLASS	NO.		
			OUT WALKING
½ QTS.	NO SIR.		FEELS PRETTY GOOD
2 ST.	NO.		
NONE.	NO.		
2 QTS.	NO NOTHING DOINE.		
			OUT WALKING
			" "
1 QT.	NONE AT ALL.		
			LEFT THIS AM. FOR EXAM. OFFICIAL.
			COCOA SERVED IN DIRTY CU[P] NOT ENOUGH VARIETY IN FOOD
1 QT.	NO.		
1 QT.	NO.		
5 GLASS	NO.		
1½ QTS	NO		ACCIDENT FELL F[RO] HORSE. — INJURED NECK.° O.K.
3 GLASS	F-84/10 P.M. 188.	NO	PRETTY GOOD.
			O.K.
1 QT.	NO		
5 GLASS	NO.		SAW CUP (DIRTY) GIVEN TO LAMPHIER.
			O.K.
			O.K.
× QTS.	NO.		
3 QTS.	NO.		COLD CAMPHOR COMP.
1 QT	NO.		
1 QT	NO.		
1½ QTS.	NO.		PAIN PERSISTS IN CHEST.
3 PINTS	NO.		
1 QT.	NO.		
3 QTS.	NO.		
2 GLAS	NO.		

Dr. Harold Ayers was a physician in Groton for over 50 years. He arrived in town in 1913. Sometime after his arrival, he moved to William Bancroft's abandoned bungalow atop Gibbet Hill. Ayers set up a hospital in the buildings and cared for tuberculosis and other long-term patients. The doctor also maintained a farm on the hill, which supplied food for the kitchen at the hospital. Many of his record books and personal account books were given to the care of the historical society. This page from his patient record book details the health of his patients on May 4, 1921, and additional comments including mental health and complaints of those under his care. According to his charts, Ayers monitored health, appetite, sleep, and water consumption. Under the column marked "Remarks," Ayers jotted down items of note. One patient complained that his cocoa was served in a dirty cup, and another patient told the doctor that he "saw the cup (dirty)" given to the other man.

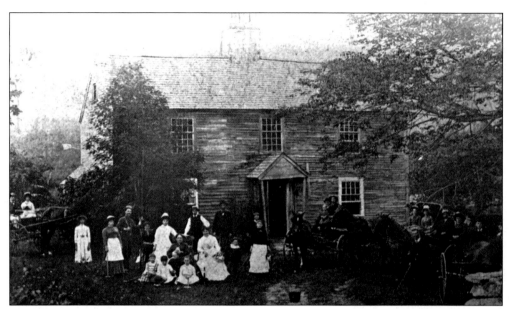

This house was known as the Aaron Wright house, and it stood on Snake Hill Road in South Groton before it burned in 1901. Snake Hill Road is an old road that was laid out in the 17th century and passes by one side of Sandy Pond. The Wrights' guests must have traveled to attend this gathering, as evidenced by the abundance of horses and carts parked by the house.

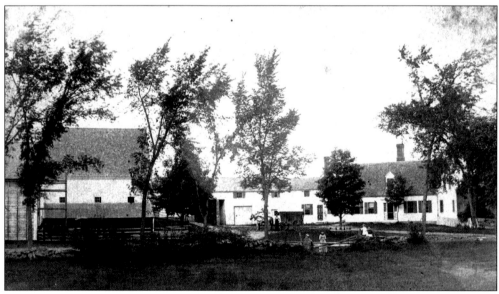

Countless buildings have burned down in Groton over the last 350 years. This farm on Boston Road is just one example. Open flames were used in fireplaces and in lamps to provide heat and light. Aggressive flames coupled with inadequate firefighting organizations and equipment left old wooden houses quite vulnerable.

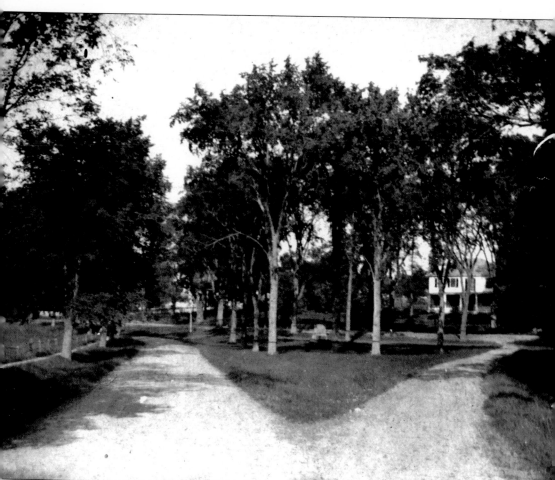

Prescott Common is home to a stone monument honoring Col. William Prescott, commander of troops at the battle of Bunker Hill, who was born in a house that stood near this spot. While Groton may have lost buildings to fire, demolition, and changing boundary lines, the town has erected various monuments and markers to commemorate these historical places or events. This particular view of Groton captures all the elements that make up the essence of the town. In a single snapshot is a combination of the natural landscape, a man-made structure, and a monument commemorating history. Each of these three elements is important in Groton's legacy: the natural landscape provides trees for shade, rivers for power, meadows for mowing, and fields for planting; the house provides stability for a family; and the monument on the lawn commemorates a place that is no longer seen but is not forgotten. On nearly every corner and every turn in Groton is another such view: a mill upon the river, a monument marking a seemingly empty field, and a stone turret on a hill, overtaken with ivy.

DISCOVER THOUSANDS OF LOCAL HISTORY BOOKS FEATURING MILLIONS OF VINTAGE IMAGES

Arcadia Publishing, the leading local history publisher in the United States, is committed to making history accessible and meaningful through publishing books that celebrate and preserve the heritage of America's people and places.

Find more books like this at
www.arcadiapublishing.com

Search for your hometown history, your old stomping grounds, and even your favorite sports team.